THE ARTIST IN TIME

A GENERATION OF
GREAT BRITISH CREATIVES

HERBERT PRESS
Bloomsbury Publishing Plc
50 Bedford Square, London, WC1B 3DP, UK

BLOOMSBURY, HERBERT PRESS and the Herbert Press logo
are trademarks of Bloomsbury Publishing Plc

First published in Great Britain in 2020

ISBN: 978-1-789940-35-0

2 4 6 8 10 9 7 5 3 1

Research and Transcription: Johanna Flato
Designed and packaged for Bloomsbury by Plum5 Limited
Printed and bound in China by Toppan Leefung Printing

To find out more about our authors and books visit www.bloomsbury.com
and sign up for our newsletters

This book was commissioned by the Baring Foundation. www.baringfoundation.org.uk.
For more information, see page 141.

THE ARTIST IN TIME

A GENERATION OF **GREAT BRITISH CREATIVES**

CHRIS FITE-WASSILAK

PHOTOGRAPHY BY OLLIE HARROP

HERBERT PRESS

CONTENTS

INTRODUCTION

Chris Fite-Wassilak

This is a portrait of a generation, a gathering of twenty British artists born before 1950. In their own words, they describe their inspirations, their daily habits and the processes they go through to make their work. These are active artists, people making work now: some have pursued a singular focus for over fifty years, others took a little longer to become artists, but all share here what they have learned along the way. For some, it is an act of collecting, progressively gaining more insights, tools and knowledge through experience; for others, it's the opposite, gradually shedding and letting go of various assumptions or hesitations until they feel able to make what they would like to see in the world.

The artists featured in this book are painters, poets, performers, photographers, writers, sculptors, dancers and directors. It is an unlikely gathering, with disparate interests and concerns, sharing only a sense of vitality and a willingness to explore. Contained in their interviews are hints for possible paths, tips towards hidden trails that could be followed, nods to books or albums that could change your life, and years of experience. Altogether, this is a collective portrait of creative practice later in life, asking how each of us create, and might continue to do so with the passing of time.

The conversations are divided into four chapters, according to the themes that emerged from our discussions: personal working rhythms; knowing your path; following luck or chance encounters; and playfulness. It has been a humbling honour for myself and photographer Ollie Harrop to have spent time with the people included this book, and I hope you enjoy the humour and honesty shared here. These artists are very much in the present, and I hope that their words might become something like the way musician Maggie Nicols describes the techniques she has developed: as a personal and collective library that is an infinite resource.

RHYTHMS OF WORKING

Getting started is always the hardest part, at any point in life. The blank page, the empty canvas, these are metaphors for our hesitations and doubts. Continuing – starting again, again and again – is another matter. How do artists begin? How do they keep going?

'Sorry for the mess', was a common refrain heard whenever Ollie and I would arrive at a studio, a home, or another workspace. Perhaps that is simply the awareness that comes with allowing someone into your creative space; regardless, the idiosyncratic means of organising were always telling. Notebooks and loose papers here and there, things leaning against the wall, these are all partial steps towards a work, initial thoughts that accumulate and are continued on a day-by-day basis. The trick, it seems, is recognising the arc of that process, whether it's hours or years, and then seeing how each day informs that wider shape. For artist Anne Tallentire, a day begins simply with her picking a random book off the shelf, to see what hits her; for musician Maggie Nicols, there's a set of tricks she uses to get herself playing and singing, depending on what day it is.

We might expect to become more habitual, more steady and measured as time goes on. A survey of older factory workers made in the 1940s, for example, concluded that there was an increase of 'steadiness of rhythm' and punctuality. Art and creativity aren't, however, jobs in themselves; as poet Wendy Cope notes here about poetry, it's something you do if you can't help doing it. One of the things that was striking in speaking to everyone included in the book was not just the sheer spectrum of working rhythms, but the ways in which each person had come to terms with their own creative output, however constant or sporadic. If anything, it was a giving over to a variable rhythm and creating an individual sense of punctuality. With some people, inspiration and the willingness to work is simply always there; for others, it comes and goes. Cope described her own recent break from writing casually and unconcerned, while the chat with Bob Fulcher coincided with his first return to writing in several years. The absence of inspiration isn't a source of anxiety, but just a natural state that is passed through.

Nicols recalls a piece of advice she was given: it's not what you practise, but *how*. In this way, it's not so much the 'benevolent tricks', as she calls them, or tips from decades of making that seem to generate these artists' working rhythms – it seems more to do with attitude and approach. David Hurn spoke contentedly of being the village photographer, happy to pop in to snap the neighbourhood children's birthday parties, all the while keeping in mind his larger, schematic approach to capturing life in Wales. There is an acceptance that some things take their own time, over days and decades, that paces change and that with the growing awareness of the body that comes with advancing age, there can be, as Tallentire and Cope both note in their own way, an accompanying acceptance of your own mind. It's there that each artist seems to find their tempo.

MAGGIE NICOLS

Born 1948 in Edinburgh, lives in London and Drefach Felindre, Carmarthenshire

Nicols is a composer, singer, actress and improvisational vocalist, who has performed with countless groups and ensembles, including the Spontaneous Music Ensemble and Centipede. She was a co-founder of the Feminist Improvising Group and, in 1991, the ongoing inclusive improvising happening 'The Gathering'. In 2014, she founded the Create-ahh Community Space.

SELECTED RECORDINGS

2019
 I Am Three & Me:
 Mingus' Sounds of Love

2019
 Glasgow Improvisers Orchestra &
 Maggie Nicols: *Energy Being*

2013
 Maggie Nicols, John Russell, Mia
 Zabelka: *Trio Blurb*

2002
 Charlotte Hug, Caroline Krabbel,
 Maggie Nicols: *Transitions*

1993
 Joelle Leandre, Irene Schweizer,
 Maggie Nicols: *Les Diaboliques*

1985
 Maggie Nicols and Peter Nu:
 Nicols'n'Nu

1978
 Maggie Nicols and Julie Tippetts:
 Nicols/Tippetts

When I was a child, my mum and I would talk in a made-up language. That was my first experience of interacting with someone on an improvisational level. I think improvisation is a kind of birthright, really. It's something everybody does, even if we're not always aware of it. Humming to ourselves, for example. Spontaneous expression is powerful in its own right, or sometimes we can choose to go on and shape it or structure it into a song, or poem, or so on.

I wanted to be a ballet dancer, really. But I was told I had boys' knees and I wasn't suited for it. So thank you, boys' knees! I don't think I could have coped with being a ballerina. My mum always hoped I would be a star in musical comedy, and I went briefly to a stage school for acting, singing and dancing. When I was fifteen I left school, and got a job dancing at the Windmill Theatre in London, in their semi-nude revue. When the Windmill closed, I got my first singing job in a strip club in Manchester.

Many of my earlier transformational moments came about by chance: through people I wanted to impress, through people I fell in love with or had crushes on, or through a yearning to be part of something. I went into a music shop for inspiration, and noticed a young man buying a trumpet mouthpiece. I got taken to Ronnie Scott's jazz club for the first time that night, and it just so happened there

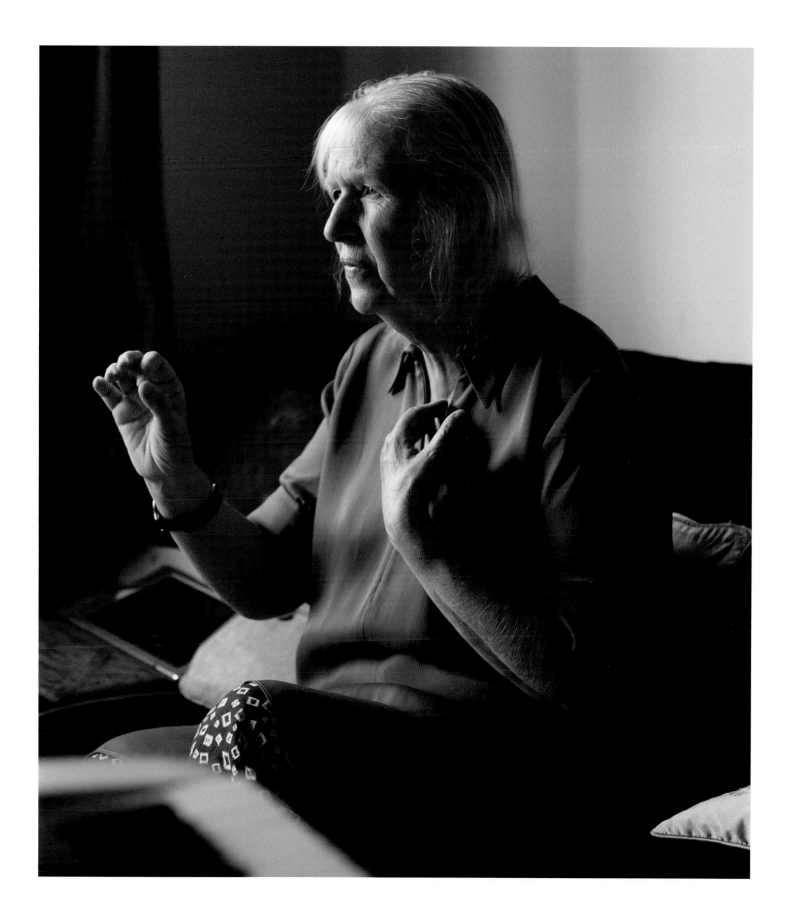

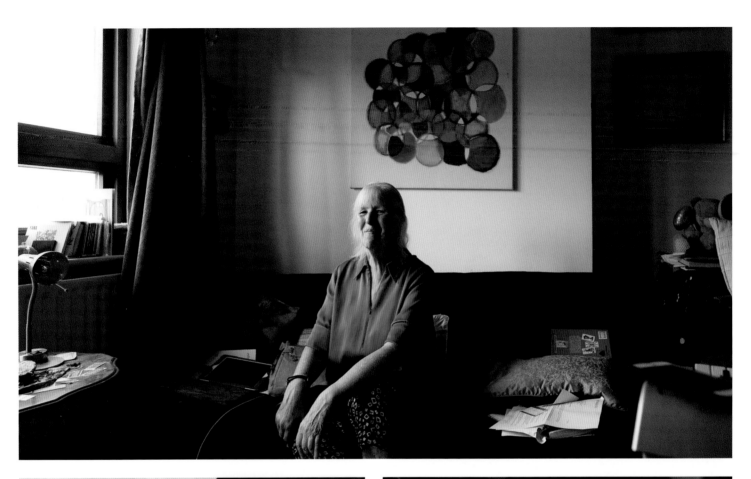

he was, playing. I got an immediate crush, and because he played trumpet I went and bought a Miles Davis EP. I haunted the club, and a genuine love of the music took over. I desperately wanted to sing, but unfortunately more often than not I was taken advantage of rather than helped. Some people are cruel to you, some people are kind to you. And you learn through that.

I've never trained officially in voice or piano. I realise now my training was serving apprenticeships, informal mentoring, and being around lots of different musicians. When I started hearing free jazz being played, I could hear where a voice could be within that music. Not long after, I started singing with the Spontaneous Music Ensemble, one of the pioneering groups of free improvisation.

I THINK IMPROVISATION IS A KIND OF BIRTHRIGHT, REALLY. IT'S SOMETHING EVERYBODY DOES, EVEN IF WE'RE NOT ALWAYS AWARE OF IT.

I love practising and yet, do I deny it to myself? Sometimes, yes. I've devised all sorts of what bassist Gary Whitteley calls 'benevolent tricks' to get myself doing it. I start every morning with meditation, and then I have a set of ideas for when I'm not in the mood for music practice, depending on what day of the week it is. Monday is the moon day, the lunar day. So I think, 'Well, what is the moon? It's more intuitive.' So I have this very beautiful meditational piece that was shared

with me by pianist Pete Nu: you just sing or play one note, accompanied by the piano, for about five minutes, and then go up semi-tone by semi-tone doing the same thing. I put all the desire to improvise into that one note. It's a lesson on conserving energy because you can get possessed. If I've got time, I will do that for about an hour or more. I call it 'one note leads to another'.

Often I'll take a tuning fork out for a walk. Then I can do the same exercise wherever I am; if I've got an 'A' tuning fork, say, I might start on the 'F', you know, a major third below the 'A', I might do the octave, and then I might do the intervals. I'll play and make little riffs and experiments. This practice has been the best thing that ever happened to my voice. It has helped my breathing, it helps my imagination – you're hearing all these possibilities and you're pouring it back into one note. It's good for finding all sorts of different aspects of tone and dynamic. The first time I did it there was a room full of saxophonists, and they could be much louder than me. So at first I would try and compete with them, and I would wreck my voice. And then one day I decided, 'No, I'm just going to keep to the level that's comfortable for me.' And I discovered that by conserving energy my voice became stronger. Recently, I've been doing one note for a whole week. I'd been doing the exercise more as a spiritual sort of focusing and grounding, but I'm actually finding from just doing that one note, my vocal range is extending.

Then on a Tuesday, which is Mardi, Mars's day, I might do some five-finger exercises, because that's more martial. Wednesday: Mercredi, is about communication, so I do some learning, I might learn new pieces or do some sight

reading. Thursday, Jovedi, Jupiter, I think of us 'expanding', so I might do compositional study, looking at various composition books to generate ideas. Then Friday is Venus's day, so for pleasure I sing and play songs. Saturday is Saturn, structure, so I'll maybe do scales. Sunday is fun day, free play. I just improvise. I know once I start, I love it; it's just getting a way to start. Just turn up, as they say. Because often the resistance is masking a deeper feeling.

I practise and compose in other ways no matter what day it is! I once asked Trevor Watts, 'What do you practise?' He said, 'Well, it's not what I practise. It's *how* I practise.' That had a profound effect on me. It's practising with awareness. Sure, you can sit in front of the telly and practise, that's useful on a mechanistic level and it will make a difference. But I particularly love practising when I'm fully engaged, so it's not separate from how I perform. My practice is my performance, my performance is my practice. Some things I like in all their unadulterated glory, and other things I do get when they need structure or edits. I guess it's just finding when the mediation is helpful. But a part of me wants it all, warts and all. I do think there's a place for the flaws and for the authentic voice as it emerges.

The Gathering, which is a free improvisation event I helped set up, still happens regularly in London, Liverpool and Wales, and I run workshops, and facilitate a mental health peer group that works with improvised music. What I'm about, really, is just sharing what I call 'practices of freedom', that have come out of my own mental health issues and all my life experiences. Anything you do already can be done with awareness and be made magic. I mean, look

at mindfulness. It's breath, isn't it? And breathing is never the same. Sometimes it's really flowing. Sometimes it's quite erratic, or you're feeling a bit panicky, or you're bored, restless or tired. You develop your own little bag of tools that you know that you can fall back on. But it is fascinating just trusting that: anything you do already, just do it with awareness. I think of it as a personal and collective library, it's an infinite resource.

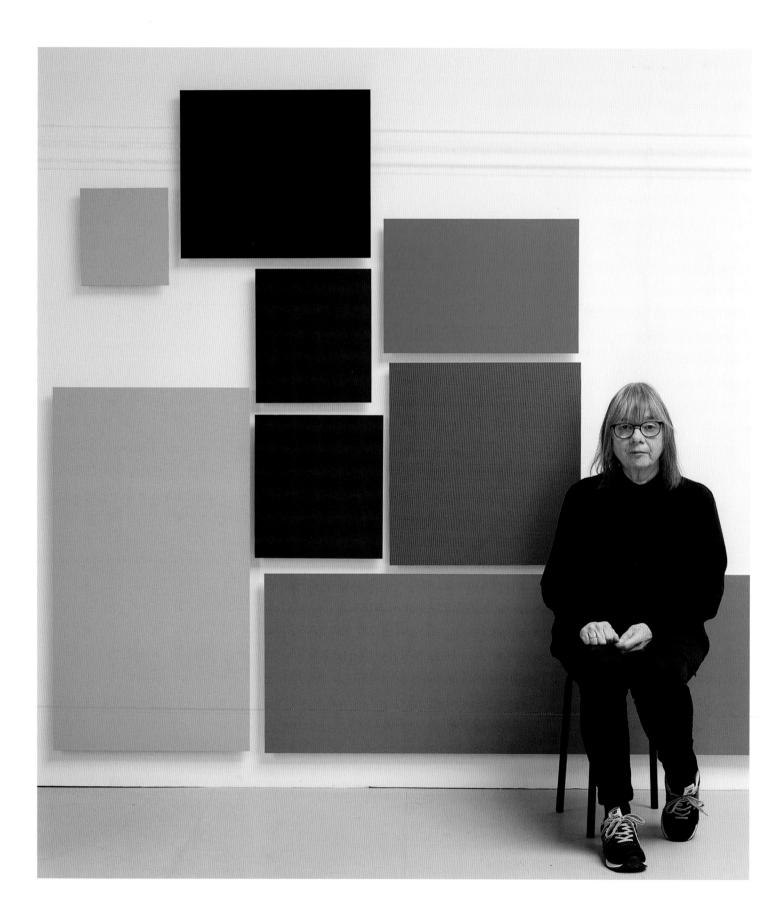

ANNE TALLENTIRE

Born 1949 in Portadown, lives in London

Tallentire is an artist who works with performance, photography, sculpture and video. She taught at Central Saint Martins from 1989 to 2013. Since 1993, she has also worked with artist John Seth as 'work-seth/tallentire'.

SELECTED EXHIBITIONS

2020
The MAC, Belfast

2018
Grazer Kunstverein, Graz

2017
Dallas Museum of Art, USA

2010
Irish Museum of Modern Art, Dublin

1999
Ireland Pavilion, 48th Venice Biennale

SELECTED PUBLICATIONS

2013
Object of a Life (Copy Press)

2010
This, and Other Things (Irish Museum of Modern Art)

1999
Anne Tallentire (Project Press)

The work I do is like a tide on a swamp: pools of water that come up, you can see them for a minute and then they go back down again. You might just happen to walk along and step into one, or you might not. It's a bit mercurial, and still I'm trying to come to peace with the peculiar way I have of working.

I left school at sixteen. I wasn't able to get a portfolio together to go to art college, so I apprenticed to a landscape painter. I did that through my early twenties.

I think I found my direction through my interest in literature. That was the window through which I managed to begin to develop my life. Through wandering into bookshops, reading reviews in newspapers and journals, I began to be able to broaden my ideas. I was actually somewhat discouraged to read anything other than nineteenth century art history, but by force of will, developed my thinking. I started to read philosophy, feminism and poetry, things like Samuel Beckett, Rilke, Sylvia Plath and Emily Dickinson. It was a very slow burn.

I was making these semi-abstract paintings that were to do with looking at the earth, looking into deep space through colour. I was interested in the markings that were made by the cutting of turf, which I read as a kind of inscription of labour into the land, not a million miles from what I'm still doing. At one point, I took some canvases and hung them

from the ceiling, and walked around them. When I did, I started to think that a painting wasn't just an object sat on the wall as a representation of thought, separate from the world. I began to think about the problematic relationship we have to place and space, and the related dimensions of everything. That was when my work began. Since then, there's always been this underlying seam or spine of my practice, which is action: making an action, doing an action, thinking through an action of some sort.

I went to New York and studied printmaking at the School of Visual Arts on a part-time basis in 1983; and then came to London to study on the Slade's experimental media postgraduate course. Up until then I had had no formal education, but at the time, I was doing these kind of performative drawings, making body markings on paper, and the Slade took me in. I couldn't believe it, and the rest of my life as an artist took off from there.

When I'm starting a piece of work, my approach is quite random. I might come to the studio and pick any book off the shelf, like John Cage or a catalogue on building techniques, and what I find there may come to something or it may come to nothing, it's more about giving up to chance. I'm like a kind of mine detector, already in my head there are things at work on the way here that I then search for correspondences to. For a long time I had no studio, so I worked at home at one little white coffee table, and I had a completely ephemeral practice where I mostly worked on ideas for performances. I would take my camera out into the street and look for things. I still use the camera as a sort of mobile thinking process, but since I've started

working with objects the work can settle in a different way. Developments come out of a relationship between what I'm reading, hearing in the world or things I am just constantly mulling over. I went to a performance of Elaine Radigue's music recently, and I was in absolute heaven, because of the tiny space within which the music populates. There's no epicness about it. I really like when things are finely calibrated within a narrow range.

IT'S A FUNCTION OF ARTISTS TO UNSETTLE THE STATUS QUO, BUT NOT JUST FOR THE FOR THE SAKE OF IT THROUGH AN UNSETTLING OF OURSELVES WITH OTHERS.

I allow myself to play, slightly, in the studio. I'll take an object and set it on the floor, put a few things together in various configurations, and take photographs of what I'm doing. Sometimes I leave the objects there and sometimes I don't. Even if I can never ever do anything with it, this process is important. If I didn't have these arrangements there in the studio, sitting there bothering me for months on end, I wouldn't then come to the next thing. What I feel I'm doing is making thought tangible in this process.

I never stop working. I mean, I don't have a nine o'clock start and a nine o'clock end. I'll wake up in the middle of the night to make notes, and then be on the computer doing something or other. There has been a massive shift for me since I gave up teaching, I've got more time to try different

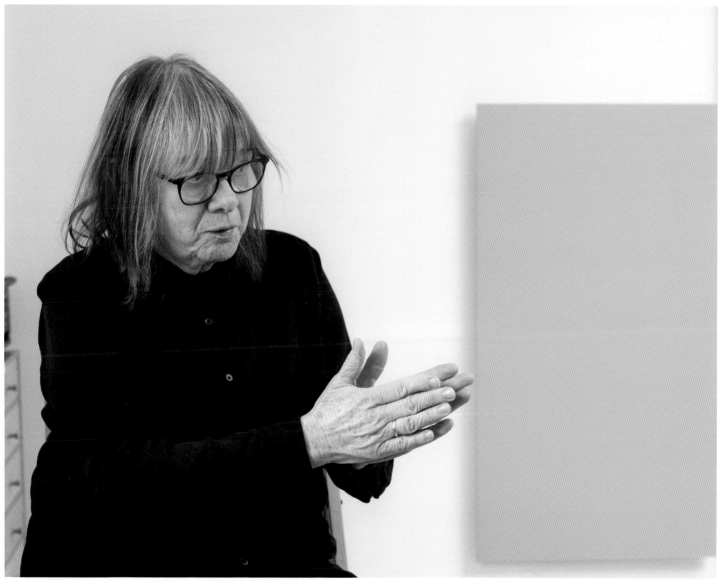

things out. When I ran a department in an art college I had to give timetables to myself and to everybody else, but now my studio time has a fluidity about it that I really enjoy.

Collaboration, a sense of dialogue and commonality, is an important dimension of my work. When I first moved to London, I volunteered to help other women to get portfolios together who hadn't had access to a further education, so that they could get through to art college. I work collaboratively with artists and writers, and help to run a series of performance events; I have these parts of my life, that all absolutely contribute to my practice, I see it as all part of this swamp-tide thing.

ON SOME LEVEL I'VE BEEN ASKING MYSELF: HOW DID I FIND A PLACE FOR MYSELF IN THIS WORLD?

A lot of my research turns out to be the work itself. A project I did in 2016 involved looking at emergency architecture, the history of the Nissen hut, and I went to Calais where an architect who helped me on the project was building shelters in a refugee camp. It was a very visceral experience. This kind of activity all gets distilled down to something very minimal, something that often sits between being a work in itself and being the process of making. Meanwhile underneath the work, there are a lot of concerns about politics. A sort of bubble that's constantly there.

My recent work has been looking at living and dwelling, the politics and economics of architecture. There's an office block in Harlow that was on the news, that is being converted into homes. What interests me is, how much space is legislated for people to live in? I guess this might stem from when I came to London, I didn't have anything and lived on a warehouse floor. I don't make autobiographical art, but there are historical notes and narratives that inevitably inform what I do. Issues about location and dislocation have always been there in my work. I suppose on some level I've been asking myself: how did I find a place for myself in this world?

I think it's a function of artists to unsettle the status quo, but not just for the sake of it. I think it's trying to make sense of the world, through an unsettling of ourselves with others. It gets harder as you get older, you have to accept certain limits that are forced upon you, to do with your physiology. But the reverse is that you have developed have a kind of muscle that enables you to take more risk. I used to live in fear of people finding out about my unconventional life, I lived in fear of getting it wrong, of being told I was in the wrong place, that I didn't know enough. Over the last while that's dropping away, I'm less fearful and more uncompromising. And that leads to unexpected things. Recently, I've been gathering bits of video – vignettes, almost tableaus – that have a theatrical quality to them, that seem totally different to what I've been doing, but maybe that goes back to my performances. It may lead to nowhere, but there's a shift, something creeping in, I don't know how I'm going to deal with it but I'm going to have to see where it goes.

BOB FULCHER

*Born 1946 in Barnard Castle,
lives in Leeds*

Fulcher is a retired farm worker.
He has been a writer his whole
life, but only started sharing his
work after his diagnosis of young-
onset Alzheimer's Disease in 2009.
He took up painting recently, as
well as co-writing a short play that
was performed at the Every Third
Minute Festival at Leeds Playhouse.

SELECTED PERFORMANCES

2010–2018
 There is Always Help, Leeds

2018
 I See Land Ahead
 with Dominic Gately, Leeds

Do you know, I couldn't tell you to this day why I picked a paintbrush up. It's so alien to me, it's like me picking up a gun. I used to hate art at school. I mean, dread. I used to try and miss the classes. Somebody said to me once, 'Can you draw?' I said, 'I'm not good at drawing. I trace matchstick men.' I started painting four years ago. For some reason I picked up a paintbrush, did a few doodles, and I thought, 'This isn't bad.' So I went to the library, got a book out, something like the 'ABC of Painting', and went from there, really. But once I started painting, there were no going back. It took me somewhere else.

I'm a dirty painter when I paint. I paint every day. I could wake up in the morning and brush my teeth and start painting, and I'd be quite happy painting until I went to bed. That's how much of an impact it's had on my life. I help out around the house as best I can, but if I were by meself, that's all I would be doing all day long. I like bright colours, and I paint lots of boats, I must admit. I like the open landscapes, because that's where I spent all my life, working in the fields. Forty-three years I was on the farm.

I've been retired for about twelve years now. I worked on a farm my whole life, and I had to take early retirement due to an injury, it nearly killed me. I always make light of it – my wife, Frances, is Irish, and in Ireland they always have a wake if someone dies, and it turns into a piss-up. She jokes, 'I knew

you'd bloody come back. You'd do anything to stop me having a piss-up!' Then I was diagnosed with Alzheimer's, which is scary. This was at sixty-three, so I was a young person with dementia. There were peer support meetings, which helped me to get painting, and to write about what was happening.

I like rock'n'roll, something quick when I'm painting. People say, 'When you're painting, do you like something melodic, like a bit of opera?' And I say, 'You're having a laugh!' I'm a big Bruce Springsteen fan. I've seen the Boss eight times. But when I'm writing, I need dead quiet, no sound at all. Most of me paintings are done from books, so it's a different kind of concentration; but when I write me verses, it's a blank piece of paper.

I call them 'rhymes', I don't even call them poems. I've written them since I picked up a pen. Whatever comes to mind. I like silly ones, with verses that rhyme. My poems are light-hearted, because I had enough with the emotion going on without writing about it. I used to find it comforting. I were bullied a lot at school, and I used go up to me bedroom and write me verses. I always wrote in private. It's very intimidating, I think, when you're bullied. I used to fear getting on the bloody bus to school. It's horrible, looking over your shoulder the whole time. With poetry, I used to find, even as a kid, I could express myself in verse that I couldn't do any other way. It was only me that used to read it; I carried on because I got to love doing it, but I still only write them for me. They trigger memories when I read them, even ones written when I was a child. When I got my dementia diagnosis, I wrote a poem called 'There is Always Help'; I

couldn't have said that to you, but I could write it down on a piece of paper. That's how I express myself.

I COULDN'T TELL YOU TO THIS DAY WHY I PICKED A PAINTBRUSH UP. IT'S SO ALIEN TO ME, IT'S LIKE ME PICKING UP A GUN.

It's two years since I wrote anything. I think I'd lost the whole confidence in writing because it's that long since I picked up a pen. But when I started, it were just like I'd never stopped, just word after word. I wrote two last night. It just shows you, don't it, never give up. I even tried my hand at writing a play a few years ago. I enjoyed the process, imagining being stuck on a boat with my old best mate, and what we'd get up to. It was good to see it all coming together, especially when you see an actor who you know off the television playing you!

I try to live within twenty-four hours, like today's today, yesterday's gone, and don't worry about tomorrow because, you know, there might not be a tomorrow. I've got a good life and it's stress-free. And it's the first time in a long time that that's been like that. I always enjoy writing poetry as much as I enjoy painting, so I'll probably do both now. I just have to make sure one doesn't overtake the other. There'll be no stopping me now, watch out for the book.

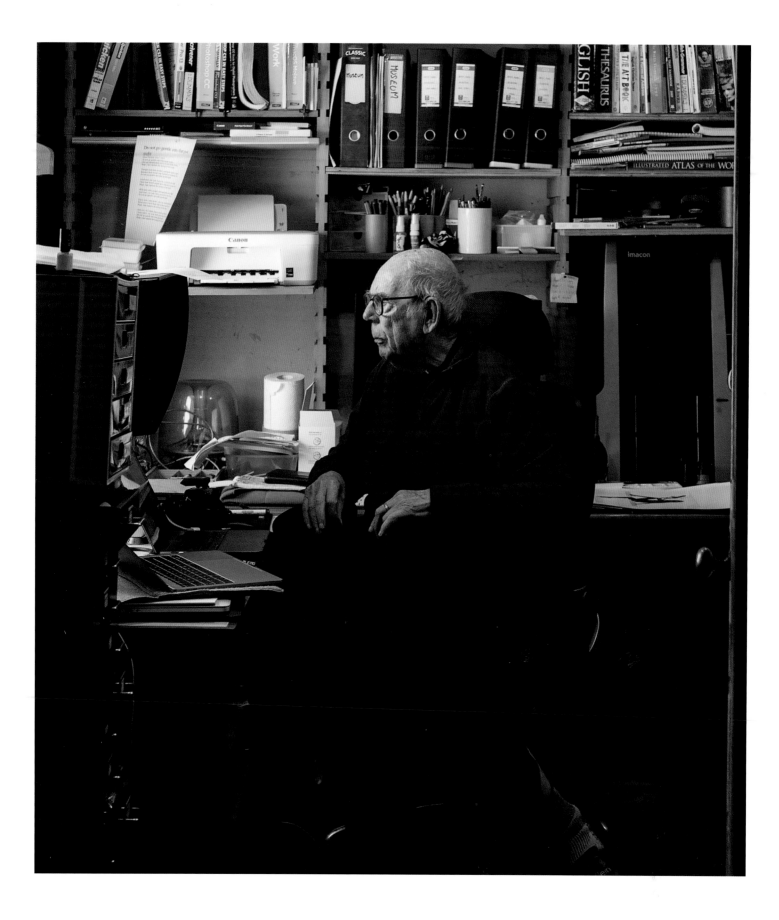

DAVID HURN

Born 1934 in Redhill, lives in Tintern

Hurn is a photographer, who has documented the 1956 Hungarian Revolution, the Beatles, Jane Fonda, and most extensively his home country of Wales.
He was founder of the School of Documentary Photography in Newport, Wales, and has been a member of the Magnum Photo agency since 1967.

SELECTED PUBLICATIONS

2017
Arizona Trips (Reel Art)

2015
The 1960s Photographed by David Hurn (Reel Art)

2010
Writing the Picture (Seren)

2000
Wales, Land of My Father
(Thames & Hudson)

1979
David Hurn: Photographs 1956 - 76
(Arts Council of Great Britain)

All a camera can be is a box with a hole in the front. It can't be anything else than that. And we all have only two controls: where do you stand, and when do you press a button? That's it! It's wonderful. The miraculous, bizarre thing about photography is that we take lots and lots of pictures — presumably, every time I press the button, I press it for a reason. Then I look at the pictures, and they're crap! And I think, why the hell did I do that, why did I take that picture? But that's part of the process.

The basic core of my photography is that I'm interested in the world out there, and that hasn't changed. My very earliest memories are visual, seeing Sir Frank Brangwyn's huge twelve-foot-square painting of a First World War tank and soldiers, and a naughty statue which I only much later realised was Rodin's *The Kiss*, at the museum in Cardiff. I'm very dyslectic so I couldn't do any written examinations at the end of my schooling, but luckily I was exceptionally good at sports. I went into the army for the National Service, and it happened that the guy who was the of head the Royal Military Academy at that time wanted a particularly good rugby team, so suddenly I was being asked if I wanted to go to Sandhurst. It was like going to university, quite fun and a good life, then one day I was in the officers' mess and I opened up a copy of *Picture Post* magazine and I started to cry.

There was a picture of a Russian army officer buying his wife a hat in a department store in Moscow. I never really saw my dad during the Second World War, and when he came home the first thing he did was to take my mum, with me in tow, to a big department store in Cardiff, and he bought my mum a hat. I suddenly realised that this image created an amazing emotion in me. I kept thinking over the

THE MOST IMPORTANT PICTURE IN MY LIFE, UNDOUBTEDLY, WAS FROM A COLONOSCOPY. THAT PICTURE SAVED MY LIFE!

next few days, isn't this extraordinary? There was this thing you can do with a camera, which makes you cry, perhaps it can make you angry or perhaps it can make you sad. To be able to create emotion seems to me an extraordinary facility to have at your fingertips. Not only that, it seemed to counteract propaganda: at that time, the enemy was Russia, but I believed those photographs more than the sophisticated propaganda I was getting. I'd never shot a picture before, and my family shot very little for the family album. But I suddenly remember saying to a friend, 'I think what I actually want to be is a photographer.'

I came up to London and sold shirts at Harrods for nearly a year. Then in the evenings I just started to go and shoot pictures, all I had was a little folding camera. I shot the most pictures in coffee bars, where I also met a lot of people. One of the things that I learned quite quickly is that the doers attract doers, and talkers attract talkers. I also had the luck to find myself among a close group of photographers of roughly my age: Ian Berry, John Bulmer, Jones Griffiths, Don McCullin, Patrick Ward, and we would eat together and share information, and one just learned so much so quickly out of that sort of thing.

Some photographers somehow instinctively just go and shoot pictures, great pictures. But for other people, how do you get there? Daniel Barenboim, the pianist, said to me one of the most significant things I've ever heard. I asked, 'What's the essence of being a concert pianist?' He said, 'David, you play the piano a lot.' I realised that that's how you become a better photographer: you take lots and lots and lots of pictures, and the more you take, the more you put aside the ones that don't work, which is the great majority. You slowly begin to realise that some of them you quite like, and then you will instinctively shoot more pictures slightly like that, and refine that down bit by bit. It's just as important to know what you don't like as what you like, it takes you down a sort of path. You shoot a lot of pictures, you look at a lot of pictures; you read a lot and maybe, every so often, there's a sentence in there which seems to work for you. Gradually, that defines who you are, in a way.

I try very hard not to say, 'That's a good photograph,' when I see an image. Because, when you say that, you're not taking into consideration the context of why it was taken. I mean, the most important picture in my life, undoubtedly, was from a colonoscopy. That picture saved my life! So by definition, it's a good picture. I mean, even my dog can take an interesting picture: if I stuck a camera around its

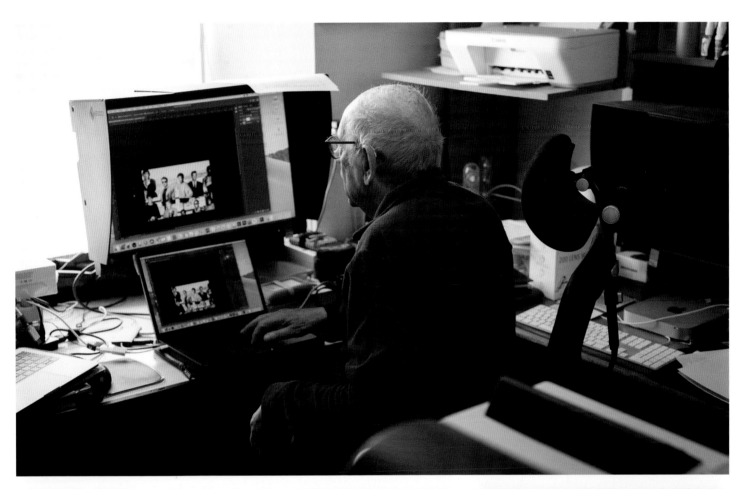

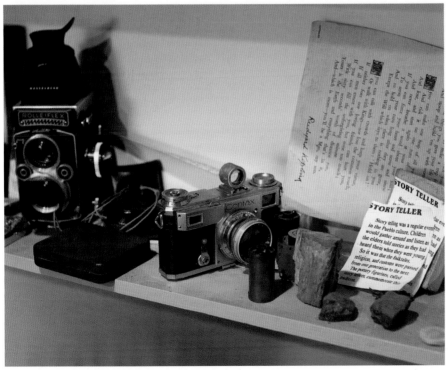

neck and it had a little timer which would shoot pictures every twenty seconds, I bet you, at the end of the day, it would produce a good picture. What the dog can't do is to produce a set of pictures that means something. You can't tell without knowing exactly the context of what is taken, and sometimes you can't judge it unless you've given it time.

One of the things I do is to go somewhere and try to think of maybe four or five pictures. In simple terms, the equivalent of the portrait shot, the equivalent of what I would call a relationship shot, that is, the subject in relation to somebody else, and the equivalent of the establishing shot, like you get in movies. I do everything in that kind of way. If I was to go to

a sheepdog trial, for example, I need to visually know where it takes place: what is the difference between it taking place in Aberystwyth or in Ysbyty Ystwyth. When I came back to Wales in the seventies, I felt it was a size that perhaps you could deal with, so I thought, I'll try to discover, in pictures, what for me is meant by the word 'culture' here. One of the problems is that half the time one person in the debate is talking about farmers on the land, and the other person is talking about switching a light bulb on and off at the Turner Prize. So I used what I call my 'spider's web' approach, mapping out areas from the main subject of 'Wales', and then out of that I'd put 'education', 'industry', 'sport', 'culture', etc. Then under 'industry', I would break it down to 'steel',

'coal', 'mining', 'slate', 'iron', 'gold', and so on for each section. If you do this, you end up with maybe a hundred and twenty different things, and each one I would photograph as a separate little story. With a bit of luck, I would get what I call a 'living picture', which is an iconic picture, out of that story. In a way, it's like doing a jigsaw puzzle. You don't know what the final picture is, you know what it's going to be called. But you put in the pieces of the jigsaw, and gradually they come together and make an overall picture.

I realised early on that I was genuinely interested in rather mundane things, like people cleaning uniforms, army officers buying their wives a hat, or the equivalent – what Don McCullin called 'tinsel society', or John Updike calls the 'exotic of the mundane'. If I hear anything is not going to be around or disappearing, then I instantly go and photograph it. There was a town in west Wales that has actually been told that in forty years time it won't be there anymore. I did a little bit of research and I found ten towns like that, that have all literally been told the same. I think that's an incredible, interesting story to do at this time. How do you tackle it? Still, now, my idea of bliss is something happening in the village; this weekend there's the agricultural show. I'll be down there, happy photographing people with their big carrots and things. I just enjoy that recording for history, but it also might fit into any one of the jigsaw puzzles I'm working on at the time, whether the Tintern garden show puzzle, or the Wales puzzle.

I try to photograph every day. I'm obviously not as fit as I was, I can work for about three hours a day. I'm very aware that I don't have that many years left that I can physically

do things, so I've started to do a project about Tintern, because I know that even with a Zimmer frame, I could put a little tripod welded on top and get around the village and photograph. In a way I've now become the village photographer: I have my own little slot on the Tintern village website, and often somebody phones me up and says it's Johnny's birthday party next Tuesday. I'm delighted to be there. There's always new things to photograph: tomorrow is different from today. So the mere fact that I wake up tomorrow means I've got new subject matter there.

WENDY COPE

Born 1945 in Erith, lives in Ely

Cope is an award-winning and bestselling poet, who has been publishing since 1986.

SELECTED PUBLICATIONS

2018
Anecdotal Evidence
(Faber and Faber)

2014
Life, Love and the Archers: recollections, reviews and other prose
(Hodder & Stoughton)

2011
Family Values
(Faber and Faber)

2008
Two Cures For Love: Selected Poems 1979 - 2006
(Faber and Faber)

2001
If I Don't Know
(Faber and Faber)

1992
Serious Concerns
(Faber and Faber)

1986
Making Cocoa for Kinglsey Amis
(Faber and Faber)

I'm not surprised I grew up to be a writer. I'm surprised I grew up to be a poet. Because I wasn't very keen on poetry as a little girl. I liked stories. When I was seven or eight, I used to write stories in my spare time. I think everyone who is going to grow up to be a writer does actually write as a child, not just what you're made to do at school, but as a hobby. I used to tell people I wanted to be a writer, that's what I thought I wanted to do. And then I sort of forgot about it.

It came back to me in my twenties; I remembered that that's what I'd always wanted to do and realised there's no reason I shouldn't have a go. I was teaching in primary schools, which involved doing a lot of creative work with children in music and in poetry. Around the same time I began living on my own. That was quite important, the fact that there was no one at home to talk to. I was also in psychoanalysis, and I was getting in touch with all these feelings I hadn't been aware of. Those things came together and got me going. And one Saturday afternoon, I sat down and wrote a poem.

I got excited about writing poems. To begin with, it wasn't even with any thought of getting published. It was just something I felt like doing. When I was at university, I taught myself to play the guitar and I didn't expect that to lead to a career. It was exactly the same with poetry: it's just

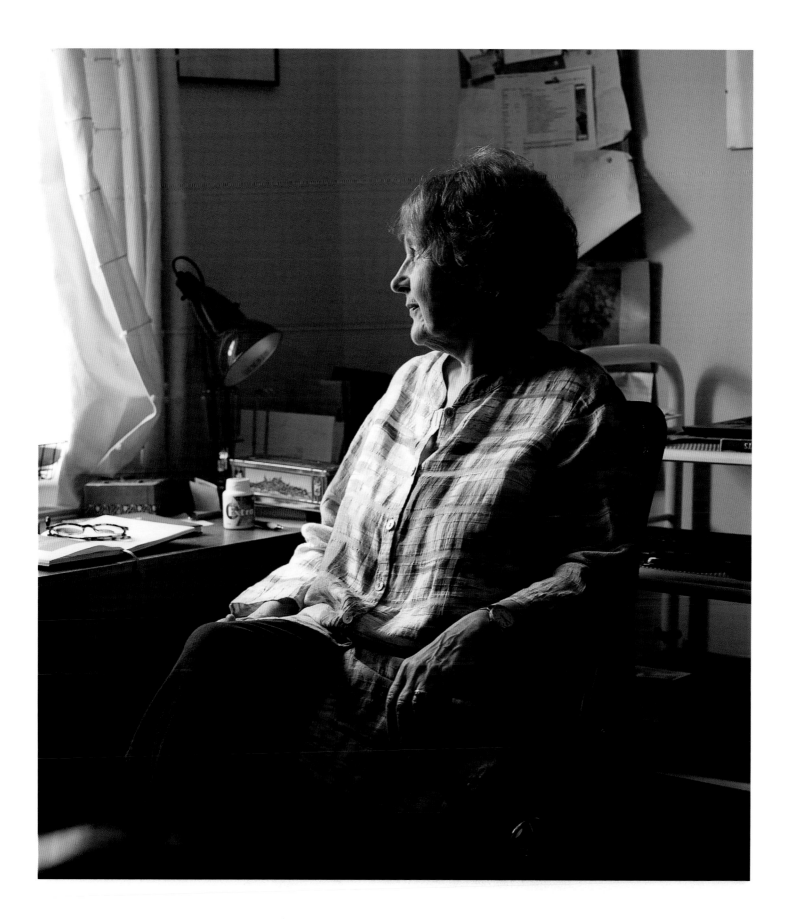

something I felt like doing. I just got really keen. I went on a short course, and what one of the tutors said was, 'Most of you on this course have got the talent to get published, but what will make a difference is whether or not you're obsessed.' I think that's right. Poetry was the big thing I was interested in. I was reading it all the time. I was trying to write it. I was obsessed.

I think with any art form – say, people who were choir boys when they were little, or friends who are very good at music – there are people who have got the talent. But they don't really want that to be their life of being a professional musician, you know? I think it has to be talent plus obsession.

I was very driven. I really wanted to get better at writing poetry. And I think – this is important – I think you have to want to do it for its own sake. I had a career in education, but a very important point came when I decided that getting better at writing poetry was what really mattered to me. Even if I never got published. At one point, I wasn't getting anywhere and I thought, 'Oh, what's the point of this? It's a waste of time. I'm going to give up.' But then I found I couldn't give up. The only good reason for being a poet is if you can't help it.

I was forty when my first book was published, so I was already too old for lots of grants and prizes, and of course there's always this problem with people who are interested in what's new, the new young rah rah rah. I waited until I had what I thought was a good book and a good publisher. Your first book is definitely your best chance to get some attention, so don't be in too much of a hurry to publish your first book. The popularity of my first book was a mixed blessing. I was very lucky, because it got attention, and lots of people started asking me to do things. At that point I gave up my day job. But the problem was that it aroused tremendous envy in the world of poets.

IF YOU CAN SOMEHOW MANAGE TO GET DOWN ON PAPER EXACTLY HOW YOU'RE FEELING AND WHAT THE PROBLEM IS, IT DOES ACTUALLY HELP.

Becoming freelance as a poet, I didn't actually have that much more time for writing. I didn't have to go to teach every day anymore, but I was still busy travelling around the country, doing readings, and dealing with all the admin and correspondence. You're never going to earn enough just on royalties from a poetry book, so you still have to do other things; the advantage of publishing a book is that this other work starts to come in, but it does take up quite a lot of time.

I've always felt as if writing poetry is squeezed in among all the other things that have to be done in life. I don't think you can really sit down and write poems all day. I spent a month at a writers' retreat once, and I did write a lot while I was there, it was quite fruitful for me. But I wouldn't want to be by myself in a Scottish castle with a random selection of other writers forever. There was one novelist there and she just sat at her desk nine hours a day. But with poetry, if I sit at my desk for nine hours a day, I haven't really got anything to write about. So I would go for walks

and I went into Edinburgh to visit the art galleries and things. I don't think you can actually spend nine hours a day writing poetry.

A poem often begins with some words, just some words that could be in a poem; you may end up dropping them. But they're the starting point. I may have been thinking about something, it may be something I've read, it may be a memory, and I think, 'Oh yes, there's a poem there.' I have a page at the back of my notebook where I write down ideas, and as long as I remember the idea, it doesn't matter if there's a delay before I can get on with writing the poem. I'll probably be working on it in my head; quite a lot of writing goes on in my

head. Then the next time I'm not busy, I will sit down and write. The Welsh poet R.S. Thomas said somewhere that everybody talks to themselves, but poets are overheard talking to themselves. I'm quite often in a room on my own talking aloud, which is supposed to be the first sign of madness.

I think some musical training is quite helpful for a poet. Sound and rhythm are terribly important in poetry, getting the meter right and getting the rhythm and the sound right. I had piano lessons and I was in the school choir, as well as playing the guitar and recorder when I was a primary school teacher. But I absolutely can't listen to music when I'm thinking or writing. If I'm listening to music, I listen to music.

Sometimes, if I haven't got an idea, I will just sort of free-associate. Sometimes it works, although I'm never quite sure if it's a good idea to try and force it. The two things I found got me going when I was having a period where I wasn't writing anything: one was writing my diary and the other was reading poetry. You have to read poems if you're a poet. That's how you learn, really. Though even reading a newspaper article can inspire, and quite often has, inspired a poem. A lot of my poems have epigraphs at the top, and very often the epigraph will be what triggered off the poem. Writing in my diary is a way to just write something every day.

There are far more poems that didn't quite work out from my early years. Of what I've written in the last ten or twenty years, more of it has turned out publishable than in the early years when I was learning and experimenting and not everything worked. I've now got a better instinct; if I've got a good idea, I can make it work. So I don't write as many poems.

Another big change in my writing life was when I got together with my husband. Quite a lot of my early work was about love affairs going wrong and being very miserable. Life got very difficult and I got very unhappy; this often produces good poems, not just for me but for anybody. Writing about it really helped me; if you can somehow manage to get down on paper exactly how you're feeling and what the problem is, it does actually help. But for the last twenty-five years or so, I haven't needed to write those kinds of poems that I wrote out of desperation. For a while, when I first moved in with him, I didn't even write much,

because I didn't need to, not in the same way. I didn't have as much time, I had to learn to shut myself away and have time on my own. Which I can do now: I have a study at the bottom of the house; he has a study at the top of the house.

At the moment I'm not writing any poems. My work may be finished. I don't get enough good ideas these days, and I seem to have lost the impulse to write poems. It may come back, it does happen. I feel I've written quite a lot, and I'm happy with a lot of what I've written. I want to enjoy my life. I'm not going to spend the rest of it feeling guilty for not writing. In the past, most poets were dead by the time they got to my age. I think I need a pause, because I've done enough of what I do. If I'm going to start writing again, I need to be trying something different. That's the feeling I have, but that may not be what happens. We'll see.

GROW INTO YOUR VISION

At one point during our time with singer Shirley Collins in her cottage in Lewes, she was describing her love of Italian Renaissance and Tudor music, and her admiration for what she saw as their honesty and directness. 'But,' she added as an afterthought, 'who can say why you like anything? It just sounds good to me.'

The offhand remark struck a chord with me. One of the questions I kept returning to over the course of these conversations was: How do we know what we like? Where do taste and intuition come from? This whole book is a rainbow of ways you might consider thinking about those issues. But some people we interviewed seemed to have arrived at something quite early on – they felt something, had a passion or interest, and knew that it had to be followed. For some, such as Collins, or the theatre director Roma Tomelty, the family environments they were raised in created a particular informal education of sorts that led towards what became a lifelong obsession. For director Ken Loach, it seems to have been a form of community

storytelling that he was seeking from early on, starting off in theatre and eventually formulating a working environment with a team, as well as a filming approach to realise the stories told in the way he wanted to tell them.

These are artists who have found a path and followed it with conviction. As painter Frank Bowling says, with a casual determination, 'I grew into my vision.' As if it were something there, formed, ready and waiting for him – and also that once he recognised it, he would not be dissuaded from it. He just needed time to develop the skills to correlate what he saw in his head with what was on the canvas. Intuition is a chicken-egg conundrum that might just depend on latent tendencies, certain situations to react to or against, and – as we will see in the next chapter – sometimes just luck. Not all of us know what we want to do, or are lucky enough to find such a singular passion. But in such an idea of a vision is also the implication that the seeds for being an artist are there right from the start, and can be found, and nurtured, at any time.

FRANK BOWLING

Born 1934 in Bartica, Guyana,
lives in London

Bowling is an artist who has been exploring the possibilities of painting since the late 1950s.

SELECTED EXHIBITIONS

2019
Tate Britain

2017
Haus der Kunst, Munich

2015
Dallas Museum of Art

1997
De La Warr Pavilion,
Bexhill-on-Sea

1986
Serpentine Gallery

1971
Whitney Museum of
American Art, New York City

SELECTED PUBLICATIONS

2019
Frank Bowling (Tate Publishing)

2017
Mappa Mundi (Prestel)

2011
Mel Gooding: *Frank Bowling*
(Royal Academy of Arts)

I came to art quite by accident. When I left Guyana in my late teens, I arrived in London to go to college, and found that the support that my parents could afford was insufficient for me to live. So I had to take odd jobs, and then signed up for the National Service. Once I was in the Royal Air Force, I became friends with this amazing man who had been to art school himself, and was doing service as a medic. I lived with his family after we left the service – his mother was an agony aunt working for a newspaper and his father was a portrait painter. During the time I lived with them, I was sitting for portraits by the father and the son, as well as his friends who graduated from the Royal College. I would also be taken along to the Tate, the National Gallery, and the Wallace Collection – a very special place to me. And looking at the work there, I decided that I wanted to try and paint my own head, rather than let the others do it. So I started these self-portraits using industrial paints, because the available colours in art shops seemed not to be able to get to the ochres and umbers in my own skin.

I struggled to find my own sensitivities to the material and paint, I was very secretive about what I was doing. I went to the Chelsea College of Art for half a term, until I had no money left except the bit I was getting from washing dishes in restaurants. I applied to the Royal College of Art, but in the exam I was told I didn't have enough 'work from life', as it was called – drawings of figures and the rest of life; I just had

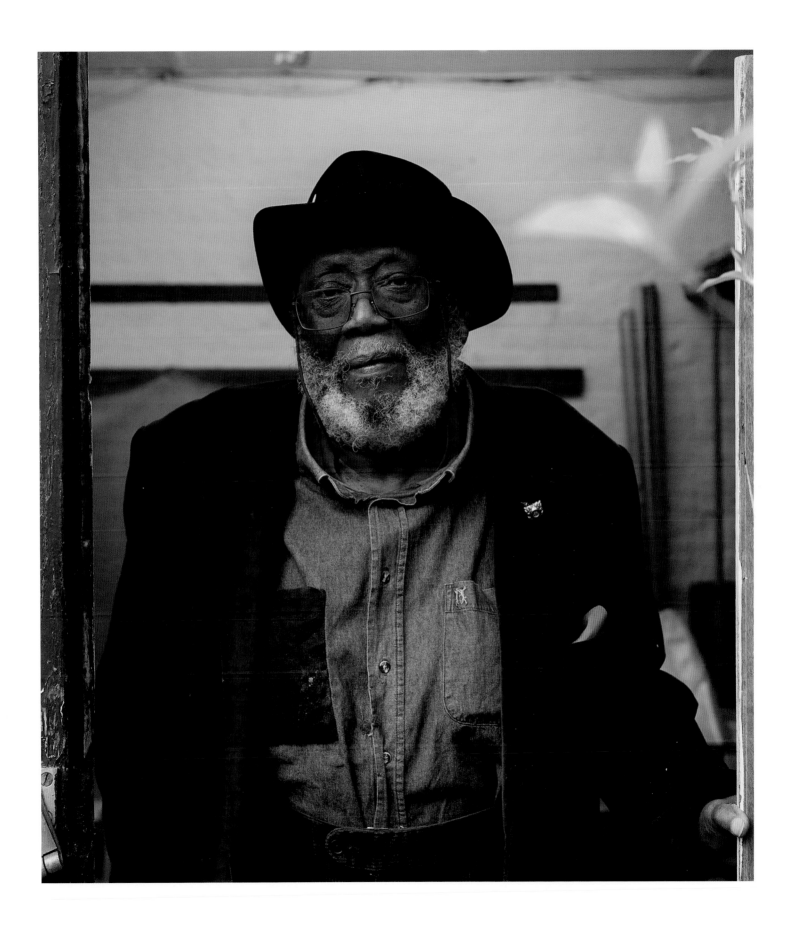

these images of my head and other imaginative things that I was concerned with, like beggars in Guyana. But I went to City and Guilds College, knuckled down and took the RCA exam again and I got in. That was 1959. And from then, I haven't stopped painting and not a day goes by without my time to paint.

I have grown into an understanding of what my vision is. Painting was something that I grew into without knowing anything about art and culture. Once I was a student, I realised that there was a certain effect of the emphasis on 'subject matter', that paintings had to be about something. I found it really hindering; the subject matter of the artist is the material that they're using and not some story, right? I was restless – I realised that my attachment, my gift, my thrust was towards the material itself. I was more prone to taking the subjects we were given and turning them into tough visual realisations. Then my work turned more to the internal structure of architecture, and the geometry of painting. Even once I moved to New York in the sixties, I found that a number of those American abstract artists took off from Turner, Constable, artists in the Norwich School. So when I came back to Britain, I realised that I could loosen up the whole thing. I became an abstract painter. And I still am, I think.

A lot of the work tends to hint at this and that. I'll read a poem by Frederico Garcia Lorca, for example, about the grey rain coming down in the turbulent sea, and the sea behaving like a bullfight arena. I've been pushing that idea of how the elements churn up and reveal really intense feelings. I suppose that's something that the work is striving

I HAVE GROWN INTO AN UNDERSTANDING WHAT MY VISION IS. PAINTING WAS SOMETHING THAT I GREW INTO WITHOUT KNOWING ANYTHING ABOUT ART AND CULTURE.

to do all the time: to realise, through the materials, the kind of feelings and tremors that go through your blood, that is running through the entire national feeling of, say, Britishness. It isn't just about the need that we all have to make marks, you know. It can involve the mark-making process as it comes out in full, like in nature itself.

Painting is a specific job. I'm absolutely regimented; I used to just simply work all day long. Sometimes in places I was living, I worked through the night. These days, not being able to get out of bed really until later, we get to the studio for the afternoon and do a couple of hours and then go back. It's an everyday thing, we just get on with the painting. All this work is done un-willed, if you can imagine that. I feel something; nerves, 'tremors' is the word I use. You see something out of the corner of your eye, and by the time you're focused on it you want to eat it, like children do. That's the stuff: I make it and I put it in my mouth.

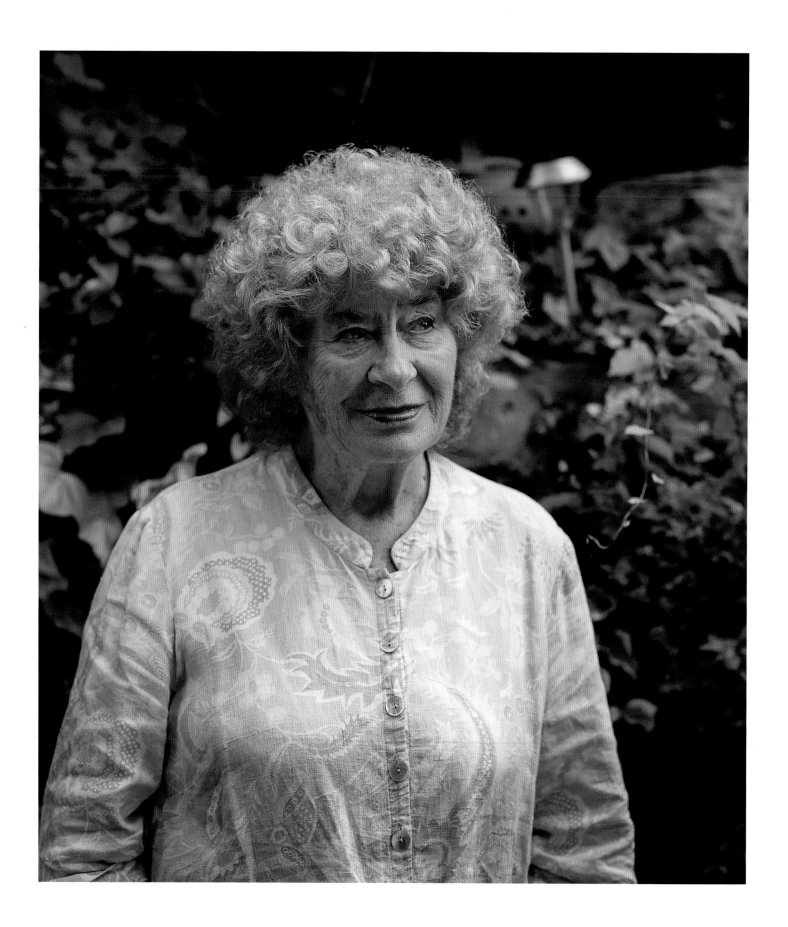

SHIRLEY COLLINS

Born 1935 in Hastings, lives in Lewes

Collins is a singer of traditional folk music. One of the key actors in the British Folk Revival, she recorded numerous albums with her sister, Dolly Collins. Retiring from music in the late 1970s, she returned to recording and performing in 2016.

SELECTED RECORDINGS

2020 *Heart's Ease*

2016 *Lodestar*

2002 *Within Sound* box set

1978 *For as Many as Will,*
 with Dolly Collins

1971 *No Roses,* with the Albion
 Country Band

1969 *Anthems In Eden,*
 with Dolly Collins

1968 *The Power of the
 True Love Knot*

1964 *Folk Roots, New Routes,*
 with Davy Graham

1960 *False True Lovers*

1958 *Sweet England*

SELECTED PUBLICATIONS

2018 *All In the Downs*
 (Strange Attractor Press)

2004, reprint 2020 *America Over the
 Water* (Strange Attractor Press)

When I was about eight, we were taught a song called 'Turpin Hero' at primary school. I remember, quite vividly, noticing that the tune sounded a bit like 'Greensleeves', which was one of the most popular tunes played on the radio. I just had this instinct right from the start, that I knew what an English tune sounded like, I could recognise it and I loved it. I've got an intelligent understanding of the music – and I value that. I have worked on it, but it feels easy to work on.

During the air raids in World War Two, my sister Dolly and I used to sleep in Granny and Grandad's Morrison shelter, a steel table with mesh sides, and to keep us kids feeling secure they would sing to us. What they sang, I later learned, were folk songs – although Granny sang some rather mournful Edwardian songs as well. Later, when I was fifteen or so, we used to listen to the 'As I Roved Out' and 'Country Magazine' programmes on the radio. Both used field recordings of English traditional singers, ordinary people singing remarkable songs from memory. They would also have trained singers, singing with piano accompaniments that somebody had written for the songs, but I couldn't bear that part. Even as a fifteen-year-old, my taste was already developed.

I grew up in a rural labouring-class family; my dad was a milk roundsman, my mum was a bus conductress and my granddad was a gardener. My family loved England,

which I find very difficult to say nowadays, because their England is not England now. My England is working-class, socialist, artistic and kind and I am pro-European. We had a piano at home that we would sing around, some madrigals and Christmas carols – we knew all the words by heart – and at Christmas Dolly and I would go out carol singing to get pocket money. Dolly bought a guitar; she didn't know how to play it, so she laid it across her knees, open-tuned it and just strummed it. We started playing and singing together as teenagers at social gatherings around Hastings.

THE PURPOSE OF IT ALL IS JUST TO MAKE SURE THIS PRECIOUS MUSIC IS STILL THERE TO BE HEARD, AND WILL CONTINUE TO EXIST AND BE DISCOVERED BY NEW GENERATIONS.

I went to teachers' training college for a year, but hated it. I wanted to do something with music, I was absolutely hooked. So I went back home and worked the summer as a bus conductress to get enough money to take myself off to London. I had been told about Cecil Sharp House, headquarters of the English Folk Dance and Song Society, and the library there. But when I got there in the fifties I found they didn't want people in the library it seemed, especially not a young working-class girl, and it took me ages to get access. But I persisted. There were collections of folk songs, and if I liked the words I used to just jot down the tune on manuscript paper and take it home to Dolly to play. Then if I

liked the tune as well as the words – which I mostly did – then I learned them.

I couldn't read music and still can't. That was just laziness at first, but in a sense I'm glad, because I didn't want to learn from other people's idea of what that tune was. Ultimately, the best way to learn is from the field recordings, so that you hear the actual people, such as seventy-year-old farmers and their wives, and English gypsy singers, who were such important carriers of the songs. You hear the tune as they sing it, not as somebody who's collected it thinks it should be. I can learn a song very quickly. After a couple of years researching at Cecil Sharp House, I met the folklorist Peter Kennedy, who had made loads of field recordings in the British Isles in the fifties and sixties, and I was able to start to listen to those. Then I was really off.

You can't write a folk song. It's got to have existed down the centuries, and gone through that process of being passed on orally. Then you get drawn to a certain song or set of words. It's a feeling of which songs want me to sing them. On the *Lodestar* album, 'Awake, Awake, Sweet England' was written in the sixteenth century when St. Paul's Cathedral toppled in the earthquake, and then it turns up in 1909 in Herefordshire, and nobody's heard of it since. People must've been singing it, but nobody spotted it. I found it in a book I was given years ago, *The Folk Songs of Herefordshire* by Ella Mary Leather, full of historical bits, odd customs, birthing, funeral and wassailing customs. It's that aspect that is just so thrilling, when you find a song that just comes up once in five hundred years, it's like an archaeological dig! You've found an absolute treasure, and it's just amazing that it has survived.

My most treasured books, actually, are the two volumes of Cecil Sharp's *English Folk Songs from the Southern Appalachians*, which have the most wonderful versions of British ballads in them. The songs have been changed over the centuries, adapted to Appalachian tunes that have got their own feel, their own mode. I was in the United States in 1959 with Alan Lomax for a year, making field recordings of people in Arkansas, Alabama, Georgia, Mississippi and Virginia. I've learned and recorded some of those songs for the recent album, from the mountain women in particular. I was really fortunate to have had that experience.

You've got to trust the songs, to let the song speak for itself, through you. I am only a conduit, representing all those people behind me who sang the songs. Every time you sing a song, you remember the singer you got it from. You have to honour that length of time that song has been sung, throughout the countryside and through centuries. I want to do the song justice, I want to do the singer justice. You have to sing in your own voice with your own accent, and sing the songs as straightforwardly as you can. They are telling a story after all, and often they're attached to the most exquisite melodies.

I don't have a regular routine, but I do start days outside in my garden, just letting stuff drift in and out of my mind. I hadn't recorded an album in over thirty years, so when we made *Lodestar*, I just had to do it at home in my cottage. I didn't have the confidence to go into a studio, where I thought a young engineer might think, 'What's this old girl doing, coming in here singing these funny old songs?' I just couldn't face it at that point. But we had the windows wide open most of the summer, and the birdsong came through and we used it on a track, and just kept it going. Now there's a follow-up album, and I felt brave enough to record it in a studio, I couldn't wait to get on with it.

I've learned hundreds of songs, that bring with them a long memory that I can draw on; I feel a connection that goes a long way back. The purpose of it all is just to make sure this precious music is still there to be heard, and will continue to exist and be discovered by new generations. It was never a duty for me, but certainly something I had to do. The tradition is far too important to not tell the truth about it. It's important as, for me, music is part of the soul of a place. If I hadn't had this great belief in the music I was doing, I'd have faltered long ago. But it has been my absolute mainstay and still is, and I feel very fortunate that I have that.

JANE MAY

Born 1932 in London, lives in Sandwich

May is a teacher and performer, who since 2010 has been one of the core members of Moving Memory Dance Theatre Company.

SELECTED PERFORMANCES

2019
Love Grows, Canterbury

2018
Start Stomping, Canterbury

2016
Beyond the Marigolds, Kent tour

2014
Cracking the Crinoline, Kent tour, Brighton, London and Paris

2013
*Moving On Moving /
More Please!*, Canterbury and Margate

I've always loved moving. Whenever I've had space big enough and there's music playing, I find it really hard to keep still. If there's music in the street somewhere, and particularly if I'm out with my grandson, I can't help it. There's a feeling of being in touch with something, like the sort of buzz you can get watching a dog or a cat running, or the wind in the trees. I'm thinking about a seagull's flight with this wonderful swoop, and yet hardly fluttering its wings.

I think it's a bit of an ego trip, but I just love performing. I come from a theatrical family; my father and my brother were both actors, and when I left school I did quite a bit of repertory theatrical work. I married when I was really young and I had five children, so a lot of my time was spent bringing up children. Later, I began teaching at a Steiner school, where learning is artistically based and told through story. I got a lot of practice telling stories to children, and found that I could do it well. I think storytelling is a theme that probably runs through my life. I'm a collector of snippets – things I observe, or a bit of poetry I read, or colours I see; it stays with me. I don't write anything down. Anything I collect, I want to live inside me, not be external to me. When you're really moved by something, it will, in some way or other, change things inside you.

Everything is a story, isn't it? Absolutely everything. Each day is a story. The dance company is a way of creating

new community stories. I had been working as a jack-of-all-trades of sorts, with an initiative going into schools to create a more artistic approach to the curriculum, and later one of the other artists within the initiative invited me to be part of a dance theatre company made up of older women. I loved it from the moment I started. Individually, we tell our stories, we laugh, we share ideas, and they're woven together to create a communal dance.

We did one performance, as an example, about the path of life. We each talked about our childhoods, our memories, about people that we've loved, about sadness in our life. And all this we wove together into a one-hour performance. So we set off on this long road: it went from school playgrounds, and memories of being bullied or teased, then as young wives, with aprons on cooking for our husbands, to then being loaded down with children all around us. One woman who'd lost her wife shared her story, and I told the story of my brother who died. As children, we'd done a lot of sailing together in Devon, and when he died, I took a boat and scattered his ashes on the rivers where we sailed. It was extraordinary because they didn't sink, they danced. He was a great dancer. Our Creative Director, Sian Stevenson, worked alongside me to create the most magical arrangement for this: there was a screen across the centre of the stage, and so you can't see what's happening behind. At the point where I was speaking about my brother, other members of the company waved these small lights behind the darkened screen as he walked through it from the light into the dark. The performance ended with a wonderfully exultant, 'We're alive! We may be old, but we're still here!'

We only meet once a week throughout the year, more in the lead-up to a performance. I try to do the warm-up every day just to keep myself moving. We start each session totally free, which is liberating and exciting, and then we get more and more structure, which is a very different sensation, a refining and a focus of that energy. It's very powerful. And we do laugh together. We're a hardworking and committed community. We also try to share this joy with other older people, in workshops all over the country.

I have to live today because I don't know how many 'todays' I'm going to have. Physically, I can't do what I used to do – I'm in my late eighties: my balance isn't wonderful, and it takes me a bit longer to learn some of the moves than it used to. There's the simple fact that I don't have much future to look forward to. I mean, I don't say that in the least bit sadly. It makes me appreciate what is immediately in front of me, to see the expression on someone's face, a tenderness, a kindness that stays with me.

I'll go on performing as long as I can. I'd love to tour the world. I think it's good for people to see that old age is not as limiting as people imagine it to be. I think the other thing that's important for me – and for all of us – is: once life does become more restricted, there are more and more things that you can't do. But here's something that is expanding. Being able to tell your stories through movement as opposed to telling or writing is a way of communicating that is new, for me.

KEN LOACH

Born 1936 in Nuneaton, lives in Bath

Loach is an award-winning director of documentary and fiction for television and film. After announcing his retirement in 2014, political circumstances prompted his return to filmmaking.

SELECTED FILMS

2019
Sorry We Missed You

2016
I, Daniel Blake

2006
The Wind That Shakes the Barley

2001
The Navigators

1991
Riff-Raff

1969
Kes

1967
Poor Cow

1966
Cathy Come Home

When I was young, I was passionate about theatre: wanting to act, wanting to put on plays. I was in plays at school and when I was doing National Service, bicycling out of barracks without permission. At university, I spent too much time acting and not enough studying law – I nearly got sent down. I directed in the theatre for a brief period, but then I was married with a small child and had to earn some money. So I applied to the BBC, and was taken on a directors' course for television. My big break was to work with a group that was doing contemporary fiction at the BBC; it was the chance of a lifetime.

When I was in the theatre in the early 'sixties, the interesting questions were: How do you create a community theatre? How do you create a theatre that has connections to people's lives, and how does it intervene in the public discourse, rather than just being bourgeois comedies? So we took those ideas into television. Our model was Joan Littlewood and her company 'Theatre Workshop', which celebrated and explored working-class life. When working in television, we realised that electronic recording in a TV studio didn't match our aim, which was to make contemporary drama out on the streets. The form was stifling the content. Handheld 16mm film cameras were coming in, so we managed to manipulate the bureaucracy so that we could film outside the studio. It was amazing good fortune and opportunity, a group of young people given a prime slot

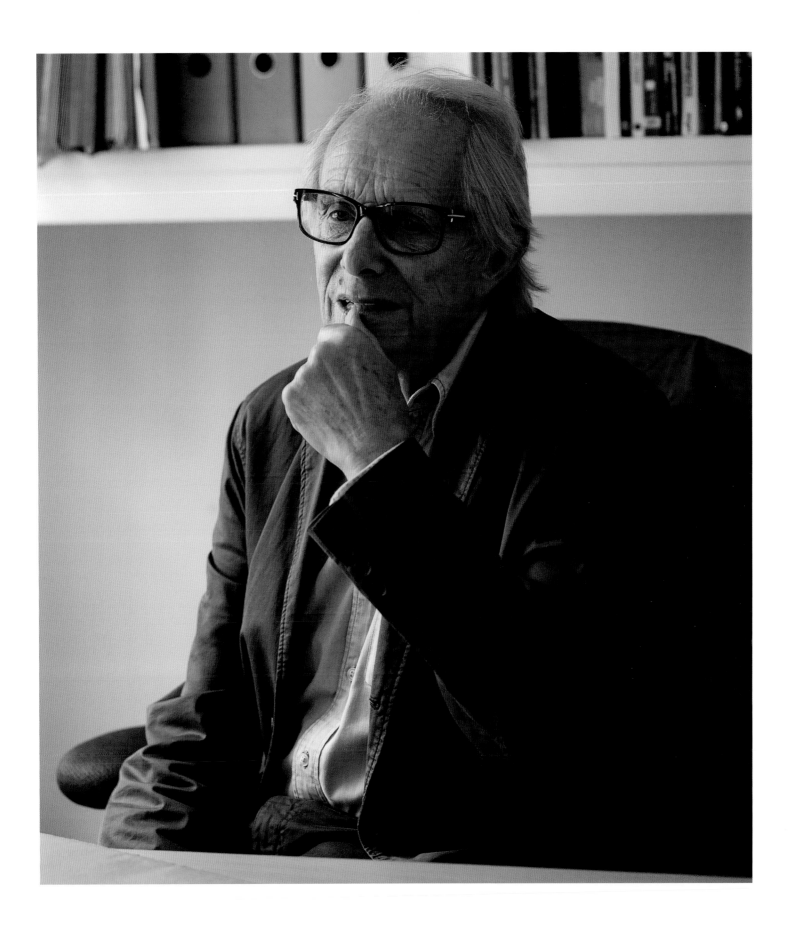

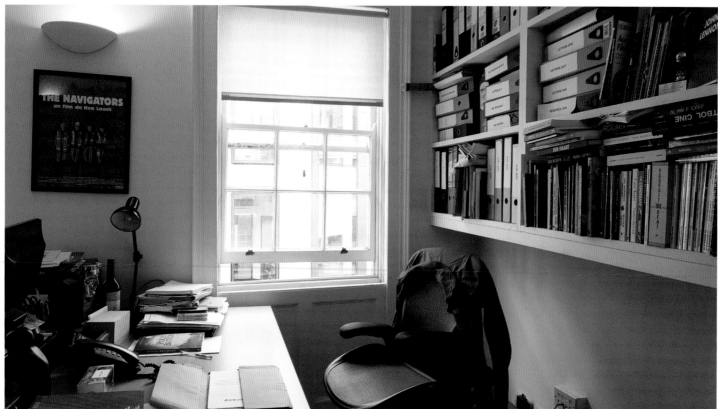

to do contemporary drama. We made one or two films for television that attracted interest and created a bit of a fuss, and out of that we managed to make films for the cinema.

Film, as a medium, is as neutral as language. It's about what you bring to it and what you focus it on. For us, inspiration comes from life, not made-up stories or other films. What inspires us to work is the real lives of real people and the tragedies and triumphs they go through. When the miners were on strike in 1984 and '85, I was desperate to make a film about it. But to do a fiction film would take time: to sift through what was happening, to choose the centre of the story, and then to work it through the consciousness of the characters takes time because fictional characters aren't all going to speak like Lenin, are they? They're humans, they've got particular levels of understanding. That's a long, complicated process that might even take two or three years. I wanted to get something topical out, so we managed to get a documentary made about the creative writing and the music of the strike, which we shot in a week and cut it very quickly. Then the TV station would not show it, and it was eventually shown some months later after a battle against censorship in broadcasting. The film was like a pamphlet saying, 'Look, this is happening now,' to say something in that moment. You could only do that as a documentary.

As a director, you work with and are led by the writers. What are the stories we really need to tell? I've worked with brilliant writers and three of them over a long period: Barry Hines, Jim Allen and Paul Laverty. Paul and I have worked together for twenty-six years. I'd have stopped by now if it were not for him. We have daily conversations

and exchange messages, football scores, gossip, politics and news stories. And out of that characters and stories will emerge. To embark on a project we have to feel like we have no choice but to make the film. There has to be a sense that 'this is a story that has to be told'. Then it's our responsibility to convey that on the screen.

THERE HAS TO BE A SENSE THAT 'THIS IS A STORY THAT HAS TO BE TOLD'. THEN IT'S OUR RESPONSIBILITY TO CONVEY THAT ON THE SCREEN.

The general rule has been 'shoot fast and cut slowly'. Because shooting is hard work, you've got to be right on your game the whole time. You've got to shoot fast to get momentum, to get an energy where everyone is fired up. It should be a creative and supportive time when everybody feels confident and valued and safe. Then people are adventurous, and take risks. As a director, you're responsible for that. I mean, I'm always slightly incompetent and forgetful and make more mistakes than anybody. So if I acknowledge my mistakes, which are frequent, then no one's afraid to do that either. Just behave like a normal friendly person, and then people catch that mood. We keep away from a hierarchy of importance: no chauffeur-driven cars, no caravans. We all travel together in a minibus because it's nice to chat. It's to do with an attitude to work, isn't it? You have to show respect for the characters in the films, too, and not exploit them with grotesque close-ups and wide-angle lenses that make them ugly. We always use lenses that approximate to the human

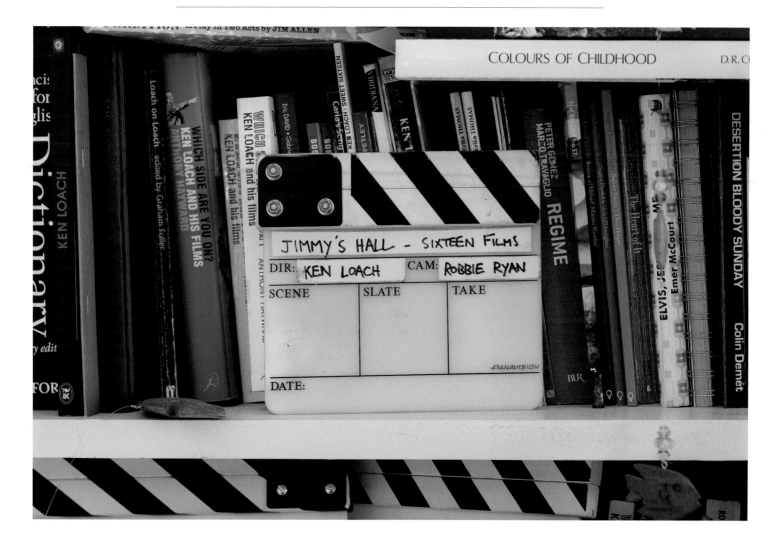

eye, and place the camera where a person could be, to give a human perspective. Then once the shoot is finished, editing is very pleasant. You can clock on at nine o'clock, get a coffee and go home at half past five. You take as long as you can over that, particularly in the winter, because the cutting room is warm and dry!

I think our films have always been made with the cinema screen in mind. That's by far the best way to see a film, because it's with an audience, not seen in isolation. We hope the audience feels like they are a person in the corner of the room just responding to what's happening in front of them. If something is funny, and somebody laughs, then that laughter is contagious. If there's a shudder, it's a collective one. Feelings communicate between people, and you get a collective response.

If you want to make a fictional film, I'd always say start in the theatre. That's where you have to make drama live. You haven't got a camera to hide behind. You have to be able to talk to the actors and understand their process. Try acting yourself, because you'll realise how vulnerable actors are,

and how you need to treat them with empathy. That's true for documentaries as well. And visit art galleries, just look at pictures; see how they frame them and how they use light; see what lens the painter used subconsciously for the picture. Filming is about light. You're not photographing things, you're photographing light. All those things you can teach yourself, actually. It's very simple if you ask the right questions.

Now I sometimes wish I could spend more time just watching the football and the cricket in the summer sun. But things are so critical and so dangerous at this present time. Politics is compulsive and also necessary. Our recent films have been stories we just had to tell, situations that have developed in people's lives that have changed the patterns of work and living. But I don't know if we'll do another one. As footballers say, 'You take each game as it comes.'

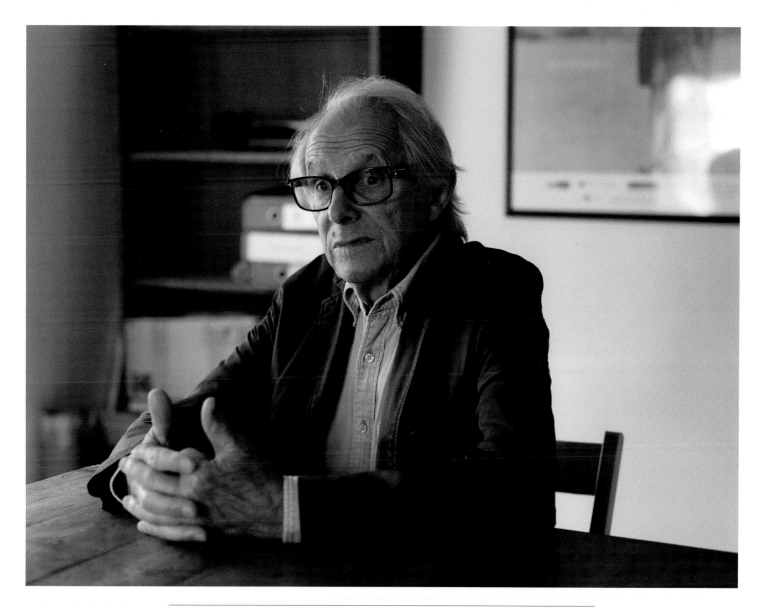

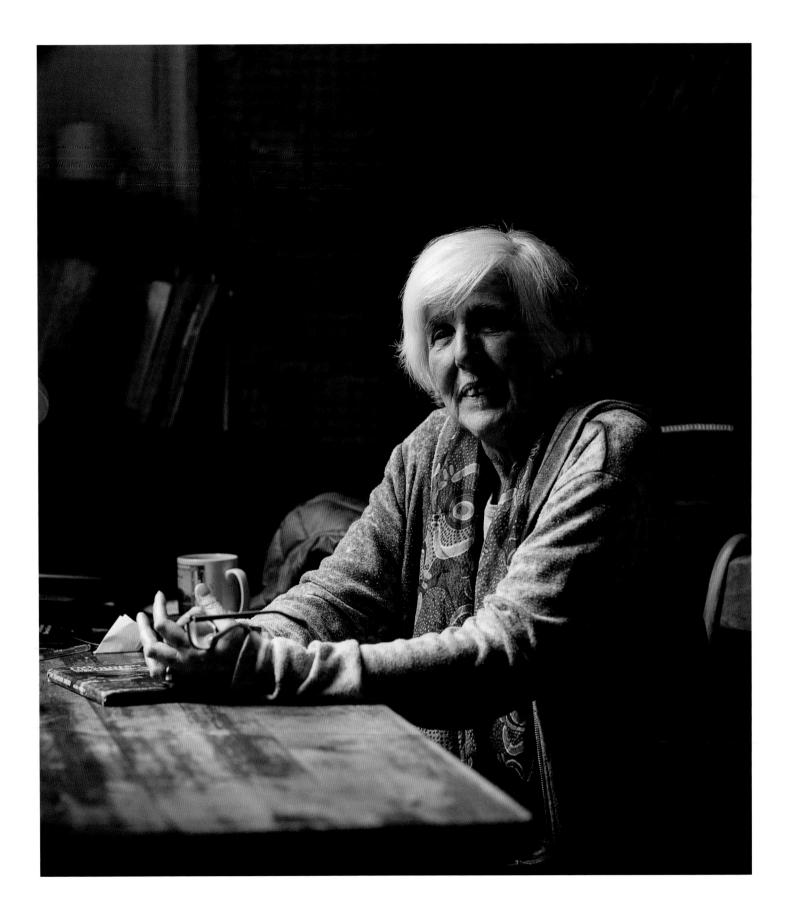

ROMA TOMELTY

Born 1945 in Belfast, lives in Belfast

Tomelty is an actor, writer and theatre director. She was the artistic director of the Newry Arts Centre for several years, before co-founding the Centre Stage Theatre Company.

SELECTED PERFORMANCES

2017
Sinners, Lyric Theatre

2013
Kennedy's Children, Belfast

2011
The Crucible, Belfast

2010
That Woman at Rathard, Northern Ireland tour

2002
Soldiers of the Queen, Downpatrick

SELECTED DIRECTED PLAYS

2017
Luther, Ireland tour

1972
Who's Afraid of Virginia Woolf? San Francisco

I never thought about doing anything else but being an actress. There was acting on both sides of the family; my grandmother on my mother's side was on stage here in Belfast in 1895, on the music hall end of theatre. My parents knew it was a tough life, and we weren't actively encouraged, but we weren't discouraged either. Growing up, if anything came to the Opera House that my parents thought we should see, they took us to see it. The BBC did all the classic plays on the television, and we'd be allowed to stay up late to watch them. We would go to the pantomimes, and if it was with my father we would go backstage and be allowed to see Aladdin's jewellery and that kind of thing, it was always a big treat. My own children say, 'Mother, you are so critical' – it's because my mother and my grandmother were hyper-critical, they would hack plays to pieces. We'd go to the pantomime, and Granny would say, 'That principal boy, not the legs of Dorothy Ward at all.' Dorothy Ward hadn't been on stage for years.

I don't consider myself a writer, but someone who can write – I wrote my first play, a children's play, out of desperation. I was running the Arts Centre in Newry at that stage, where they had a brilliant scheme at Christmas where they took six young people off the dole and did a play of some kind with them, employing them to tour it for six weeks. I would end up with a motley collection of characters: somebody who could tumble and juggle, somebody who could play an

accordion. I needed a script for six people, and I knew what it would have to be. That was really the first serious thing that I wrote, and I enjoyed it enormously. But I didn't think, 'Oh, I must write another one.'

PROJECTS MAY START WITH A POEM, OR A SONG. THERE ARE SO MANY FASCINATING THINGS, AND I FIND WHATEVER I GET INVOLVED IN THAT I CAN GO OFF AT A TANGENT.

I always write at the kitchen table. I'll say to people, 'When you have an idea, write it down.' But I myself don't do that. If I need to write something, it will stay in my head until I get to the deadline and have to do it. I'll lock myself at a friend's place on my own; we only have one car, so once I'm left there, I'm cut off until somebody comes back to take me home. I'll set up the word processor at one end of the table, and food at the other end. Then you can work all night if it's working. Coming up to a deadline, the actors are there waiting to rehearse the damn thing, so it's a real 'get on with it' feeling. I usually know the actors involved, so I know what will work and what an actor can do. You've got to trust them, and the actors have got to be given a chance to have their way. But I rarely believe in 'in the moment'. I've seen a few 'in the moments,' and a few moments I think were better not.

I'd gone back to university as a mature student, because I knew enough about theatre, but I wanted to be more educated about literature. I discovered very quickly I was not an academic, but one tutor said, 'Just sit down with something you've enjoyed and underline all the bits that you really like, and then look at it and try and work out why you really liked them.' Reading Alexander Pope's *The Dunciad* and the Earl of Rochester's poetry, I thought I'd try and write a bodice-ripper novel based on them; I never finished it. Someday when I'm gone and my children are they're clearing out they'll find it and say, 'What under God was mother into?'

We set up Centre Stage by necessity. Myself and my husband are both in the theatre, and we'd both been in Scotland for a time, and then came back to Northern Ireland for family reasons. We looked around and we thought, well we'll run a production company. It became apparent to us that nobody was doing the plays from the traditionally great period of Northern Irish theatre from the 1920s up through the 1960s, with people like George Shiels and my father, Joseph Tomelty, so that was our niche. Then it was a question of keeping going, so we opened a class, and would do the summer holiday courses for young people. 'Art for Art's sake, Money for God's sake' has been a maxim of sorts here, so we did whatever came up, really. We did murder mysteries, which were tremendous fun, and 'living history' at National Trust sites. Doing the living histories, I'd just act as if I lived in the house, coming out in this great Victorian costume and saying to the children, 'What are you doing here?' I believe in the confrontational; none of this 'we will go down a time tunnel back in time' stuff. The children just accepted it immediately, they'll believe anything if played with conviction.

My typical kind of arts day, other than actually doing anything particularly creative, is spent trying to organise

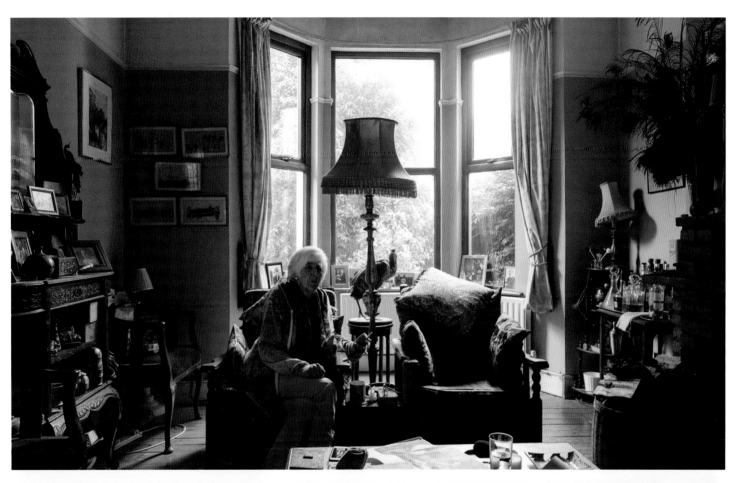

events for the company, ringing round somebody to try and sell the ideas. I rarely would have a day where I would think, 'Oh, I'm not going to do anything today.' It's a question of just maximising the opportunities, and seeing if it's worthwhile keeping the damn thing going. Then I might see something or go somewhere and get an idea, and I suppose that's a creative thing in itself, to think, 'Actually, that would work very well.' It's instinctive. And immediate.

I care passionately about what we put on the stage. I went to one production where an actor playing a soldier during World War One was drinking whiskey from a screw-top bottle, and you think, 'But they weren't invented until 1930!' That attention to detail is my passion. The designer at Centre Stage said to me one day, 'We need something on that wall.' I said, 'Well there's a corridor going down there, put a light so that they don't break their toes.' He said, 'You know, I never thought about it like that.' People are living in your room that you are designing! It has to be right. If you're going to tell the story, the audience have got to believe it. If you want to abstract it, please do – I've played in a lot of modern stuff in a black box, it doesn't worry me. But if you're trying to persuade people that something's real on the stage, then it has to be perfect. It's too often just, 'It'll do.' But it won't for me.

Projects may start with a poem, or a song, or something will flash up on the news that I'd like to know more about. There are so many fascinating things, and I find whatever I get involved in that I can go off at a tangent. We did one play about Thomas Moore's Irish Melodies and the genius pianist who accompanied the play had studied Chopin. I thought, I'm going to have to write something, so he can

play Chopin, and I could play George Sand. It all comes about like that, with me constantly thinking, what can I do? What can we do now? I presented a programme recently for the BBC about different aspects of the paranormal and supernatural. It was wonderful! I'd love to do a book of really good ghost stories, where the last line makes you go, 'Oh, no!' I love stories like that. I keep thinking of brilliant last lines. It's the beginnings that I can't pin down.

MARGARET BUSBY

Born 1944 in Accra, Ghana, lives in London

Busby became the UK's youngest and first black publisher when she co-founded Allison & Busby in 1967. She went on to be editorial director of Earthscan, and since the early 1990s has been a freelance writer, broadcaster and editor. In 1992 she edited the influential anthology *Daughters of Africa*. In 2019 she received the Africa Writes Lifetime Achievement Award from the Royal African Society.

SELECTED PUBLICATIONS

2019
New Daughters of Africa (Myriad)

2000
Kadija Sesay and Courttia Newland (eds), *IC3: The Penguin Book of New Black Writing in Britain* (Penguin)

1995
Joanna Goldsworthy (ed.), *Mothers: Reflections by Daughters* (Virago Press)

1992
Daughters of Africa (Jonathan Cape)

1990
Sarah LeFanu and Stephen Hayward (eds), *Colours of a New Day: Writing for South Africa* (Penguin)

When you're young, you're idealistic and think: 'The world ought to be like this,' or 'Why don't people do that?' There may be all sorts of good reasons why those things haven't been done, but you're not old enough or experienced enough to be put off. So you decide, 'Well, this is what I'm going to do, because I believe in it.' Allison & Busby, the company I co-founded, was conceived while I was at London University. I met this other student called Clive Allison at a friend's party – we chatted, discussing what we might do when we graduated. We were both interested in poetry and we thought, 'Why don't we start a publishing company?' So, long story short, we did. We started with three poetry books, cheap paperbacks that young people like us could afford. We didn't know how many copies to print, so we ended up with 15,000 poetry paperbacks and no distribution. Our distribution was stopping people in the streets: 'You want to buy a book?' That's how we started. We published whatever we wanted to, books we believed in, things that nobody else was doing. We didn't know any better. Someone once said to me: 'You never knew what A&B was going to publish next but you knew it would be interesting.'

I was always interested in writing, literature, words. The first words I remember learning to spell, at the age of four, were 'necessary', 'fascinating', and 'picturesque'. To me, that sums up life: necessary, fascinating and picturesque!

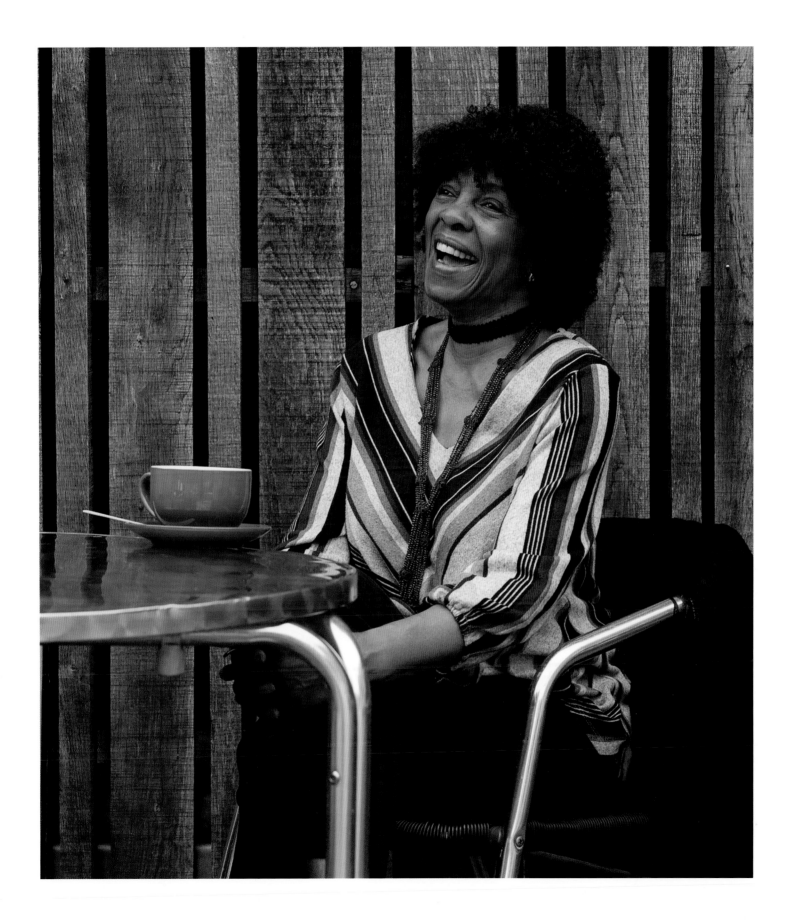

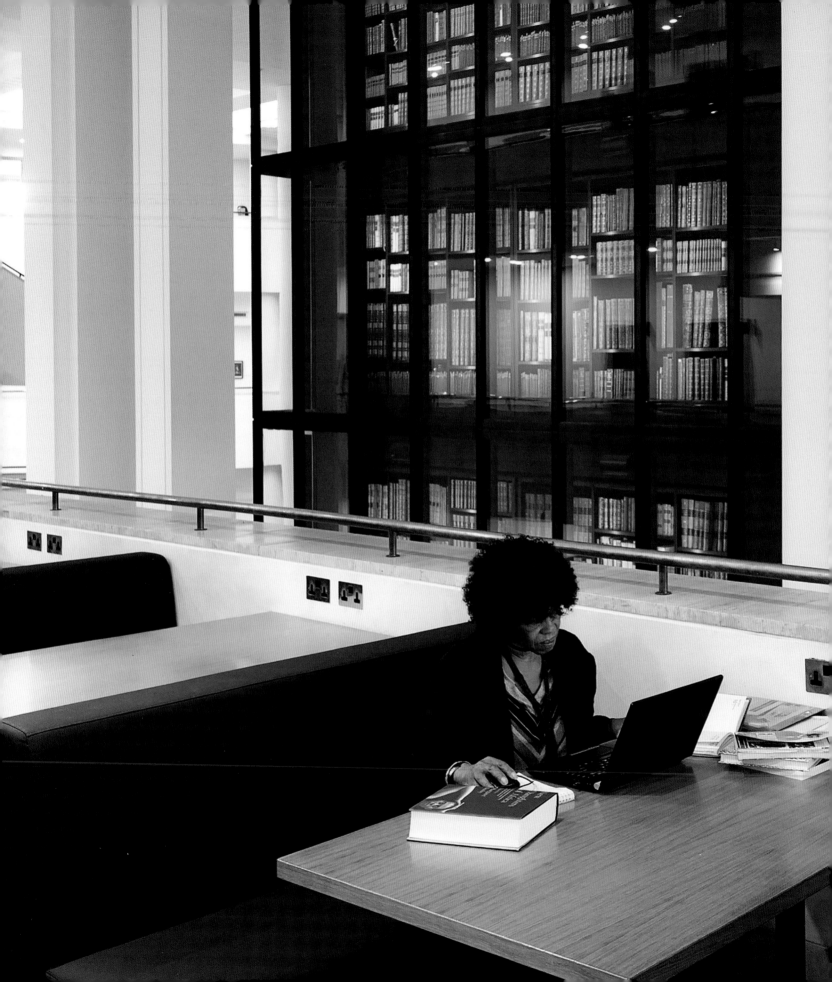

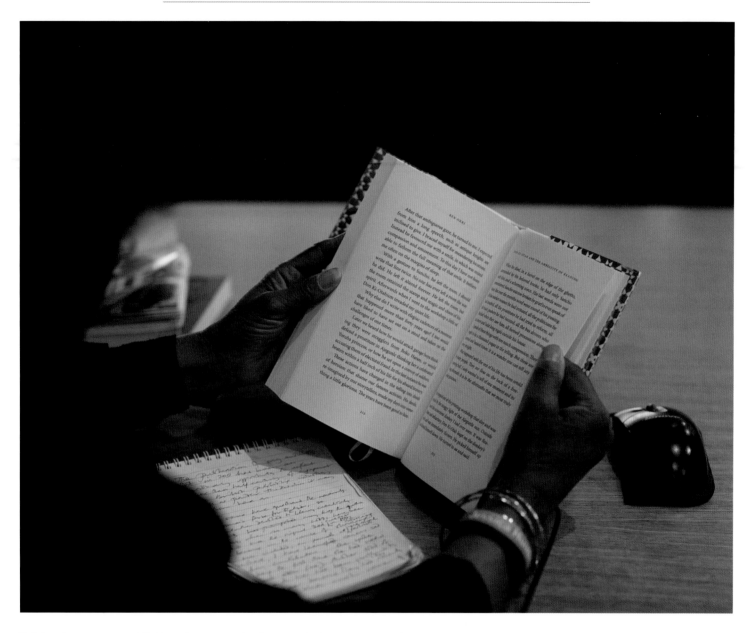

Editing is a strange skill. If you're a good editor, and do your job well enough, nobody knows you exist. People will just praise the book, and praise the author. Having a close relationship with writers, you hope to see them develop and get better and better. That's part of the joy of being an editor: it's not an ego thing. You're not seeking personal acclaim, even though you may play a part in steering a writer towards success. It's a bit like being a midwife. One writer I worked very closely with was Buchi Emecheta. We were both young African women in London, and there was not much that reflected us in the literary world. She was a great storyteller, and she had a lot to overcome in terms of her personal life, but she trusted me when it came to editing, and I would retype her manuscripts, incorporating the

changes. Editing is something I can't help. Whenever I read a newspaper, I seem to spot every typo, every misplaced comma or apostrophe. I enjoy helping people say what they want to say in the best possible way. Why wouldn't you want the world to be full of wonderful writing?

Writing my own material is a different sort of project. I'm a late-night person, and I love to hear music as I work – quite a lot of jazz, but it can be anything. I don't have a dedicated office, so when it's cold my bed, with my laptop, is my office. One of the things I've learned about myself: if I have to write something by the end of the month, I'll probably do it the day before the end of the month. Writing close to a deadline can be a good way of focusing; I guess it's to do with first recognising what you want to say and then making sure you've said it. But for me also the writing process often happens as I'm doing other things. While I'm shopping, it's going on in my head. I walk a lot, yet I'm writing. There may be no written evidence for weeks, but actually I'm constantly rehearsing it in my head so that when I pull out the computer, I've mostly written whatever it is. I've also got this mindset where I write something that you or anybody else thinks is fine, but once it's in print I realise there's one word in it I should have changed. I interviewed Maya Angelou twenty-five years ago for an article in which I used the word 'happy' at one point where I still wish I'd said 'blissful'. Now, who else gives a damn? But for me somehow it's a detail that nags.

I am keen that history doesn't get lost. Archives are important; archives are people's memories. There's truth in that saying: 'When an old person dies, it's like a library burning down.' Sometimes it's simply a question of preserving or rescuing those sorts of histories and memories. Things that help us go forward because we can see where we've come from. I got here because of my father winning a scholarship and studying by candlelight so he could save money for his siblings' education. Because my mother had to save money for her children's school fees, at one point she had only one dress, which she'd wash at night and wear the next day. All those sacrifices contributed to my being here. It wasn't that I'm such a brilliant person that I did it all on my own. I didn't. One of the things I do, and think everybody should learn to do, is edit Wikipedia. There are so many gaps in information about historical events, books, films, artworks, artists, notable people in many spheres. If you search for something and there's no Wikipedia entry, it's as if that person or thing is not important. So whenever I have time and can do a bit of research, I at least start an entry to help remedy that absence, particularly of women. I like that sort of democratic approach to information. We each have different knowledge, things that we have lived through or have witnessed, that we can share with the world.

Those are the things that contribute to each of us being where we are. And we have to 'pay back', in some way, and pass things on. We can each recognise that somebody, perhaps, gave us the opportunities or the inspiration at some time to do something more than we could have managed by ourselves. We didn't do it all alone. That's the sort of creative writing that I'm now gravitating towards: to reclaim some of those histories, stories, themes; things that propel us forward, that make us do something tomorrow that we haven't yet done.

FORMATIVE MOMENTS

How does anyone become an artist? You can train for years, or you might one day pick up a pen or start singing and go from there. The path to finding your own version of creativity is unpredictable, and the things that lead to becoming an artist are often unplanned or unexpected. It is important to recognise that opportunity and inspiration come in all forms.

For illustrator Michael Foreman, a new person on his morning newspaper route as a boy was a bit of blind luck: an art teacher, giving drawing lessons, set Foreman on his way. Foreman maintains a youthful openness, still finding that one of the main creative forces is boredom, to allow for the unplanned to happen. As with former nurse Elly Taylor, sometimes when it seems there's nothing else do to, new discoveries follow. Rasheed Araeen had trained as an engineer, and was leaning towards art; but seeing a certain sculpture exhibition revealed new possibilities. Sometimes, as with the collaborating artists John Fox and Sue Gill, it might not be one specific moment, but a whole lifetime of reacting to situations, discoveries and improvisations that shape things. It is a form of looking, as Gill puts it, 'to be constantly in a learning environment'. This chapter looks at taking a chance, accepting random encounters as meaningful, and trusting accidents as a means of lighting the way forward, to see where it takes you.

MICHAEL FOREMAN

Born 1938 in Pakefield,
lives in London and St. Ives

Foreman is an author and illustrator of over one hundred and eighty books, ranging from the Classics to contemporary authors as well as his own projects, and has won numerous awards, including the Bologna Graphics Prize, the Kurt Maschler Award, and twice winning the Kate Greenaway Medal.

SELECTED PUBLICATIONS

2015
A Life in Pictures (Pavilion)

2013
The Amazing Tale of Ali Pasha
(Templar)

1994
with Michael Morpurgo
Arthur, High King of Britain
(Pavilion)

1989
War Boy: A Country Childhood
(Pavilion)

1983
with Terry Jones
The Saga of Erik the Viking
(Pavilion)

1972
Dinosaurs and All That Rubbish
(Penguin)

1961
The General (Templar)

When I was about twelve years old, I met a new customer on my newspaper round who had just started a drawing class for children. That was the most fortunate day of my life. I mean, apart from playing football, drawing was the thing I liked doing most as a child. I had no idea that it could be a job – it was only through meeting this man and being in the company of some of his much older students who were set on this kind of career path, that I realised that this could be my future. I started doing cartoons for the local newspaper in Suffolk to help finance my studies. Then I came to study in London and started working for the newspapers in Fleet Street.

When I first went to art school, I wanted to be a painter. You know, a 'real artist'. The other commercial work paid for the studies, really. But my paintings were completely abstract – it wasn't me; it didn't relate in any way to my experience in life. The newspapers began sending me to other countries to do drawings and reportage sketches which gave me ideas for stories and, more importantly, gave me locations in which to set stories. Locations became like a character in themselves.

I was led by the work that came my way, by the subjects that were suggested, or ideas that I just happened to stumble across. However, in the back of my mind there were burning issues that I wanted to do something about. The first book I illustrated in 1961, *The General*, was an anti-war book written

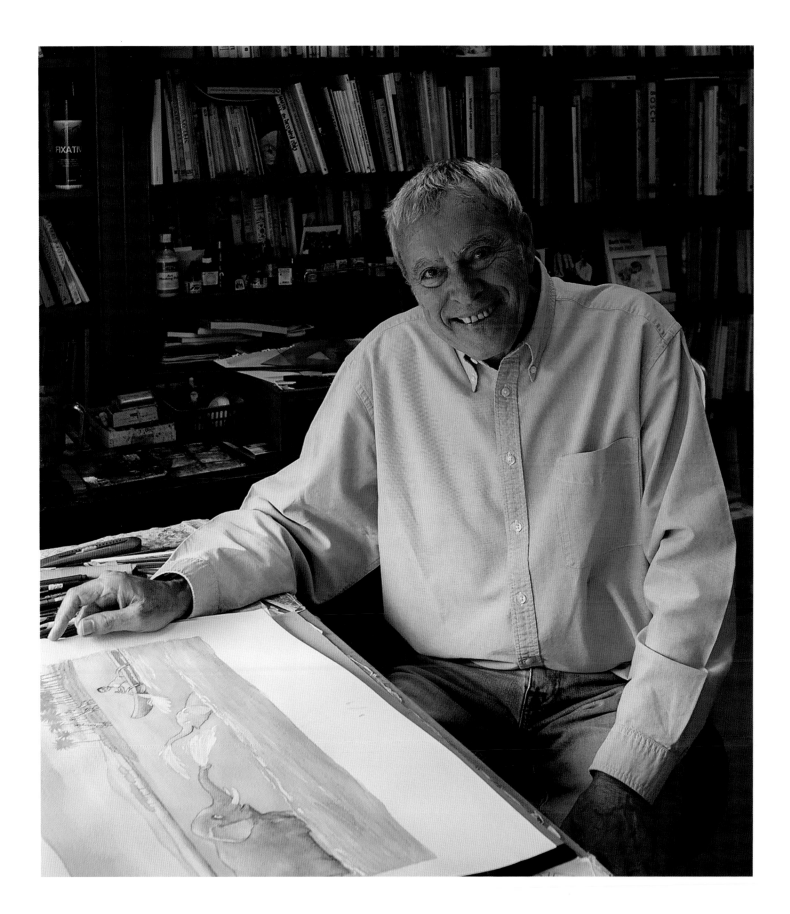

by my first wife, Janet, which was later followed by several books written by myself, including *Dinosaurs and all That Rubbish*, an early book about the threat to the environment, Since then, I've just been wanting to tell stories which matter to me and I think there's no better audience than children.

One thing fed the other: I'd make enough doing commercial work to afford to be able to spend two or three months working on a book idea. Then, after a few years, I had enough books in print to give up the commercial bit. It took

a long time. I liked doing both, I must say; you make friends with editors and reporters, you are part of a team. Here in the studio, I'm on my own. This is a lonely job in a way, except you're surrounded by the characters you're creating.

I always found that travel was a great time for ideas. I never take anything to read when I'm travelling, because I think getting bored is very creative. The brain invents stuff to work with. In 1970, the World Fair was in Osaka, in Japan, and I was commissioned to go and do some drawings there. So I went

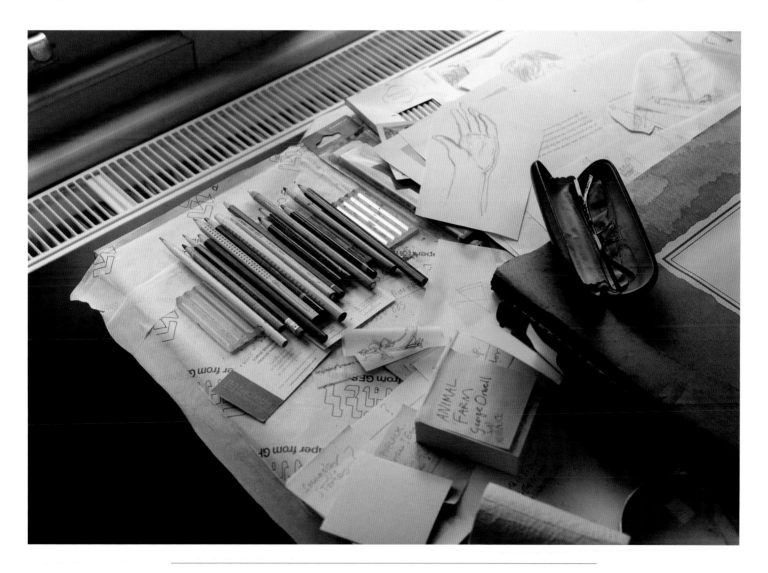

to Liverpool Street and got a ticket for the Trans-Siberian railway, going through East Berlin and all the way through Siberia and it was absolutely fantastic. For days and days you would be travelling through a forest and then, suddenly, the trees stopped. Then, for days and days, there would be the grass plains of the Steppe. It was absolutely magical, perfect dreamtime. Then, suddenly, you're in Japan and the whole thing was wild and exciting.

I've been so fortunate to have travelled a lot, it has given me so much material. Look out of the window: the world is an absolutely fantastic place. The more you experience the better; life becomes more and more fruitful. I've got shelves of sketchbooks which chart my travels. There's always one in my pocket, working out various little bits and pieces, characters, questions, whatever. I always get a new one if I'm going to a new place. In my current sketchbook, there's a high-rise building overlooking a little park full of trees. And there's this poor little tree up there on its own on top of the building. A leaf flies off the tree, off towards the park. Is there a story there or not? I don't know, yet.

There's always something to do, every day. Don't waste a minute. Ever. During the day is not when I think of ideas; the day time is 'doing' time, and 'thinking' time is night time, and travelling. I come up to the studio at about ten o'clock, and work through to a half-hour lunch, and then through to about seven. During the day, there's usually a reason to go out, to get more materials, or I will take a walk up to the heath or down to the river. One of my joys is walking from here out onto the heath; there's two or three lakes, I've set a couple of stories out there.

I'm usually working on two or three things at the same time, and they're all at different stages. If I'm stuck I'll switch to another idea. Different age groups, different kinds of techniques, black-and-white or full colour. On the floor is a pile of folders, each one is an idea for another book I want to be doing at some point. They're waiting for the secret ingredient to make it work. Sometimes these things lay around for ages, and then it could well be I'm arriving in a place and think suddenly, this is where it could work. This is a framework and the stage for the whole thing to happen. This is where the idea makes sense.

LOOK OUT OF THE WINDOW: THE WORLD IS AN ABSOLUTELY FANTASTIC PLACE. THE MORE YOU EXPERIENCE THE BETTER; LIFE BECOMES MORE AND MORE FRUITFUL.

I've been extremely fortunate, for all these years. I count my blessings every night before I go to bed, because that's another day done. Hopefully, something has appeared on a piece of paper that wasn't there that morning. And when I look at it, and sometimes I get up in the middle of the night to have another look, I hope that I'm not too disappointed with it.

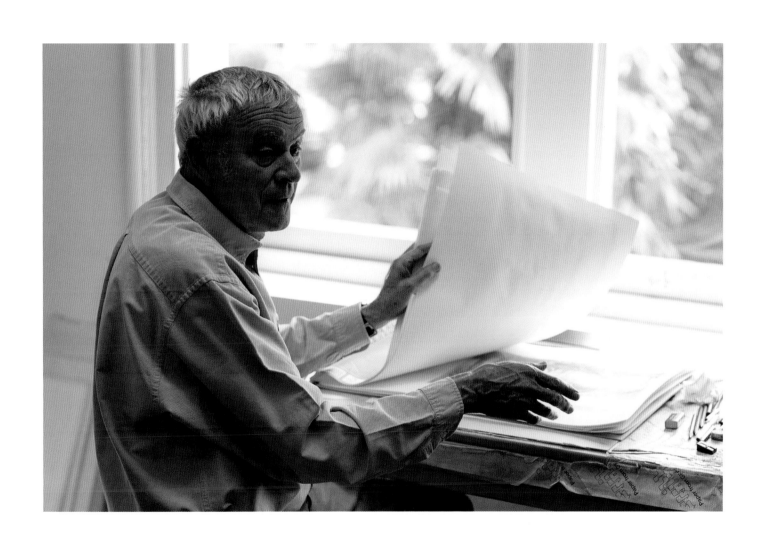

BUD EDMONDSON

Born 1940 in Bradford, lives in Perton

Edmondson is a retired professional golfer, who has been a member of a range of art groups in Perton and Wolverhampton since 2002.

SELECTED EXHIBITIONS

2018
 Wolverhampton Art Gallery

2009
 St. Christopher's Church, Codsall

I spent my life on golf courses, so I spent my life on nice, soft earth with beautiful surroundings, really. But I'll never forget a lesson I learned playing golf as a pro. We were playing in a head-to-head knock-out competition — I'm a twenty-five-year-old, and I got drawn against this guy who was sixty-odd. We got down the fourth hole, and the green isn't clear so we're waiting. I had taken my shot, so I walked ahead of him, which was a bit cocky. Then when the green cleared, I turned around and looked across the fairway and him and his caddies aren't there. The green's clear and it's his shot. There is nobody there. So I walked back and they're in the woods, and he calls me over, 'Come here, son, look at this.' They're both down on their hands and knees looking at a flower. I can't remember what flower it was. He said, 'Now look, take your time in life. Look at these flowers. You won't see many of these, you got to take your time.' We saunter back out, and he played his shot. He beat me. Eventually I thought, hello, this guy has wound me up — and when we finish, he said, 'You learned a lesson today there, son, didn't you.' I said, 'I did, thank you very much.' You do something, you enjoy it. I enjoyed golf more after that.

I don't play now. I had to retire because of arthritis. My wife was still working and I was sitting at home. We had one car, and I used to take her to work and pick her up. I remember one day thinking, 'Is this it, then?' It was simple as that. I just realised that I had to change what I was doing. So I joined a

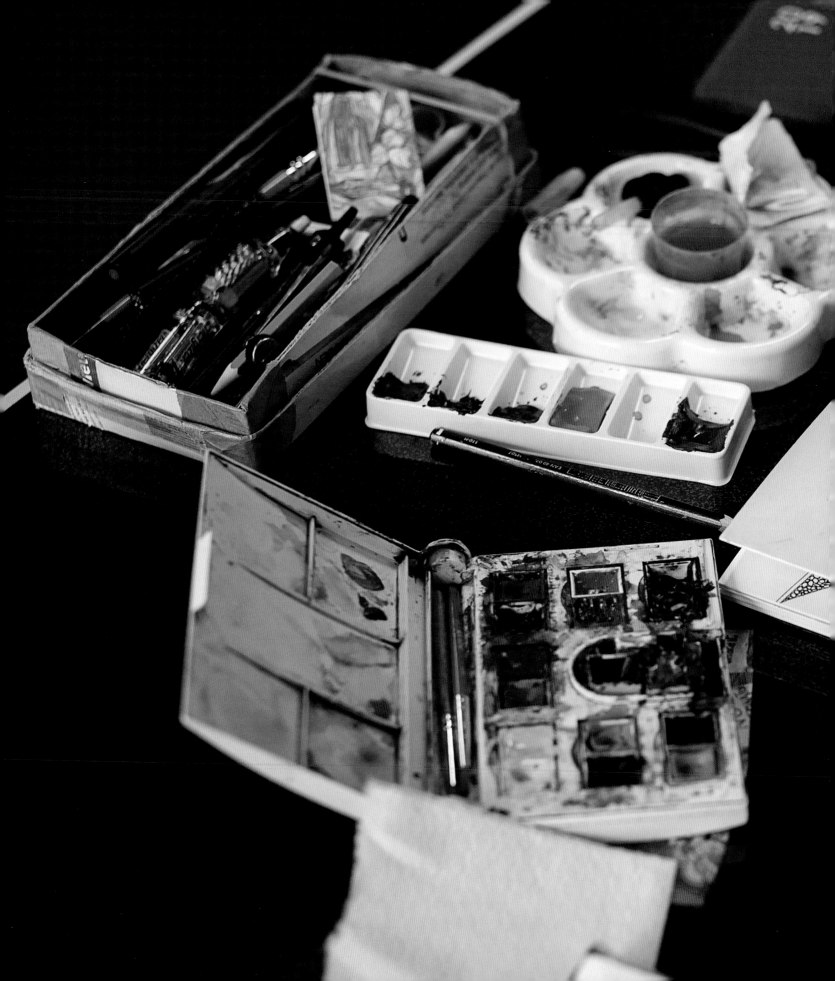

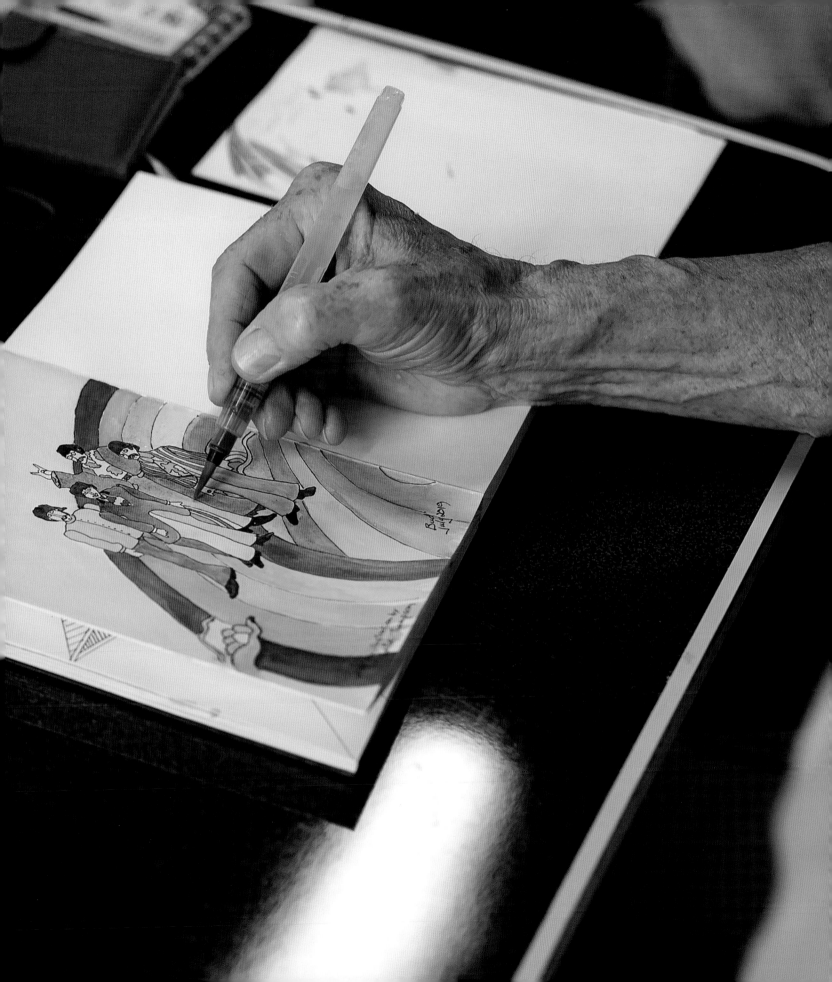

local art group. I didn't really have a clue. I'd been a person who, like a lot of us do, scribbles drawings when you're on the telephone, and as a kid I'd draw and copy things out of comics. When I sat the first day in the art group, I thought, I have no idea what to draw, nothing. And I just drew something out of my head, a scene. A sand dune and the sea and a brolly. As though there should be somebody sitting there, but nobody was. That's it. Then watching other artists, talking to people, carrying on, you develop very, very slowly.

The thing that amazed me was sitting in the art galleries. I always thought of it as a specialist place, people standing there talking about the beauty of this and that. Then the first time, going up and sitting and drawing in the gallery,

suddenly it became a different place in my memory. Also to just see these things, to look at the details, things that you wouldn't otherwise see. You spend your life doing what you do and you pass all that by. It changed my whole view of art galleries.

I have had sixteen years of learning it slowly. Like most people, I'm a very bad practiser. You know, I'd love to be a great artist, but I haven't got the practice in me, I don't focus much. I don't worry about it all the time. If you sit there wondering what it's all about, there's no point in trying to do it. I've stuck to what I am, you know? I'm not expecting to sell my paintings. I try to tell people when they go, 'Oh, I'd love to be able to do that.' I say, 'Well, you can.' Honestly,

there's nothing very special there. It's just a load of lines. As one artist at the gallery told us, he said, 'If you put a line on a piece of paper, you're an artist, and then, if you put another line and do a circle, you're drawing something.' You don't have to be clever. I can definitely say you're never too old to start. You don't have to go home and practise every day. You just start very slowly, and let it happen. It's as simple as that.

I JUST REALISED THAT I HAD TO CHANGE WHAT I WAS DOING. IT WAS SIMPLE AS THAT.

I've never had any vision, really, for my art. I don't know what my actual style is. But I've got a direction. I love drawing churches in pen. Where did that come from? I mean, I never gave that a thought in my life. I love the architecture, the stonework and the ancient feel of it. Now I'm in a period of doing lots of different things, I can't really actually explain what it is now. I love poster art, anything I see in the newspapers, or there's an advert on television for an insurance company, things I'll pick to copy details from. I could disappear mentally into the picture. I draw a lot when I'm not staring at the picture, I've actually gone into like nearly a trance. Just let it drift away and draw away. Though sometimes, I'll like something and then have to work out whether I can actually do it. Would you want to actually spend your time drawing that? Because some of the work is physically tiring and I've got to an age where I

think, 'No, I can't do that now.' I've got my limitations. When you're young, you're still firing on all cylinders. Well, one of mine is gone, and three are dodgy.

I'm still me doing what I was doing, but I do know more about it. I mean, I used to feel there was a mistake in my golf swing, but I couldn't find it. Then I found it, two years ago, long after I'd retired. I'm not saying I'd have been a great player, but there were one or two moments I know I could've just got out of the problem, because if you're having a problem, it frustrates you and you don't concentrate. It's like art; if you've got a problem, it'll affect the line you put down. But also there's the benefit of some kind of perspective; when you look at a picture you've made, you see something up front and you see it in its simplicity. But there's a heck of a lot more going behind that to get to that particular point. I've got drawings I haven't finished yet, I don't know what to do with them. And I won't do anything until I find a moment when I feel what I should do. If I don't feel it, I'll just leave it as it is.

JOHN FOX AND SUE GILL

Born 1938 and 1940 in Hull,
live in Baycliff, Cumbria

Fox and Gill are artists and performers, who in 1968 founded the performance group Welfare State International (WSI), which staged outdoor theatrical events internationally until 2006. Over a forty-year career they created street bands, carnival processions, sculpture trails, gardens, summer schools, installations and secular ceremonies. They now work as Dead Good Guides.

SELECTED PERFORMANCES

2009 - ongoing *Wildernest*, Baycliff

1990 *Glasgow All Lit Up*, Glasgow

1989 *Tempest on Snake Island*, Toronto

1986 *False Creek*, Expo 86, Vancouver

1983 - ongoing *Lantern Parades*, Ulverston

1983 *The Raising of the Titanic*, London

1982 *Wasteland and the Wagtail*, Togamura, Japan

SELECTED PUBLICATIONS

2002 John Fox: *Eyes on Stalks* (Methuen)

1996 *The Dead Good Funerals Book* (Engineers of the Imagination)

John Fox: We don't quite know why two working-class kids from Hull actually got into all this stuff. It seems to find us. It's a mystery. I made puppets as a child and I was very happy at ten years old with smelly newspaper and glue. I've gone on doing more of the same thing, really, with more fire and more people. I did a degree at Ruskin School of Drawing, but I spent all my time painting scenery for theatre shows. Then I went to art college in Newcastle and found it didn't have anything to do with the community of the city, it was essentially art history. I did performance events, which the teachers didn't like very much.

Sue Gill: I'd gone in another direction, teaching younger children, and I ended up as head teacher of one of the smallest schools in England, in the middle of the North Yorkshire Moors. I was supposed to be a pillar of society and nobody had told me; all the other teachers were older ladies who played the organ on Sundays in church and that kind of stuff. But the school was a space that was available every weekend, so we started doing events there. Liverpool poets would hitchhike over, the mothers would bake cakes, and you could feed everybody.

Then John got work at Bradford College of Art, so we moved to Bradford. The ethos at the college was that – whether a printmaker or sculptor or whatever – one day a week you did something else. So we did street theatre with people,

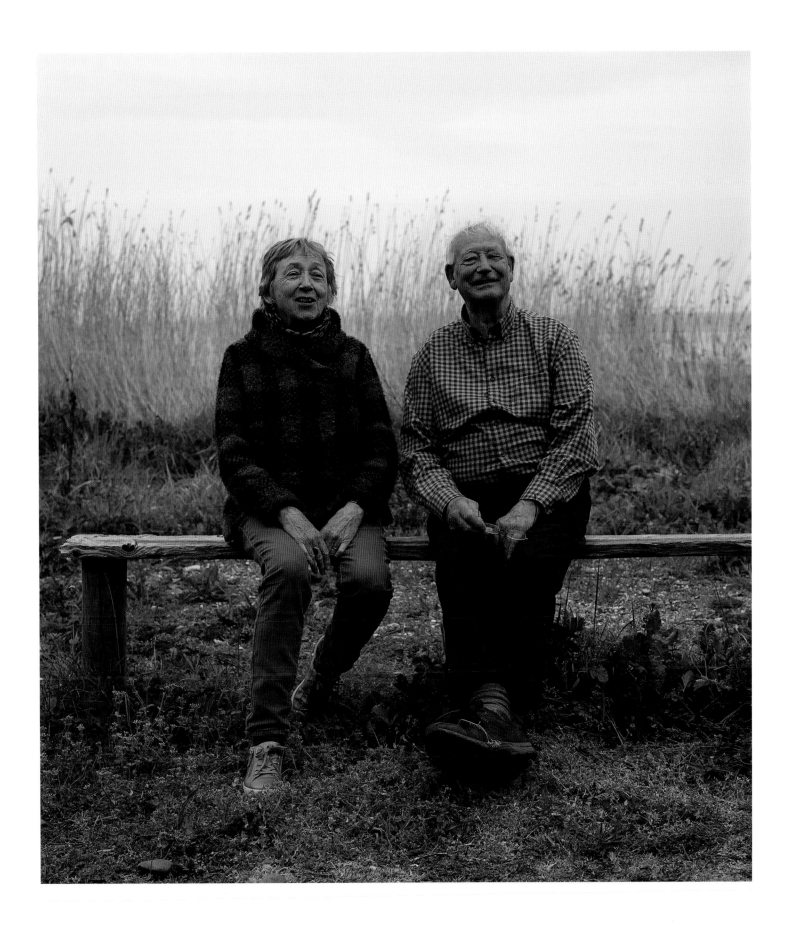

and when it got to the summer, they would go, 'Can't we just take this piece on tour this summer?' So we did, and that became the nucleus of the first six, seven people that formed Welfare State.

JF: It was 1968, and there were lots of issues, like the Campaign for Nuclear Disarmament, apartheid in South Africa, and Vietnam. The question was, 'How will you make art within that kind of context?' There was a need to get out of galleries and theatres. We felt it had become very elitist and separate; you could get free teeth and get a free coffee but you couldn't get free art. So we started the company, describing it as an entertainment and an alternative way of

life. We learned the trade on the road, really, just by doing shows. It was very simple, direct kind of folk-based events, like Punch & Judy and telling stories from the Arabian Nights. We used to collect money from the audience to get the money to get home again.

SG: We were absolutely crap. We couldn't play our instruments and we'd wonder why everyone walked off. So we'd quickly rewrite and edit on the go. It was a public rehearsal, developing our own visual and musical language, until we learned how to hold an audience. Then we started doing more elaborate one-off events.

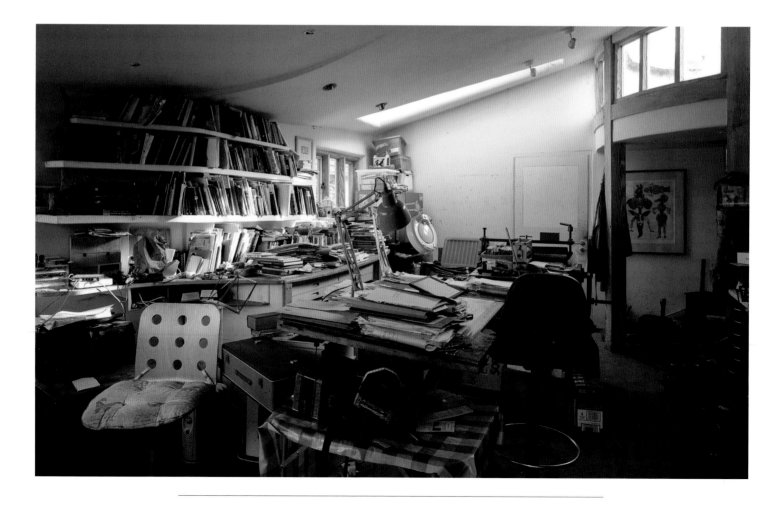

JF: We gradually started to add things like fire, or ice sculptures, or lanterns. It was a sort of fake-primitive approach, influenced by mummers, ceremonies like Bonfire Night, Halloween and seasonal events. We mashed it up and turned it into something hopefully more contemporary. But if you're in the streets or the landscape, you've got to use the tricks that people have always used: fire, loud music, dancing and big costumes.

I suppose our best skill was that we could put a lasso around a group of very disparate but very talented people, exactly like it would be in a good jazz band, where you have strong improvisers and you just give them the right chords. We weren't actors in any sense and never had been, but we attracted poets and dancers and choreographers; most people had a kind of art school training.

SG: We began to work internationally, developing a scenario based on where we would be performing, and figuring out the specific ingredients when we got there. We also ran summer schools, and things got bigger. In 1983, we did the *The Raising of the Titanic* in London. The story was an allegory about arrogance during the time of Thatcher's Falklands adventure. We'd always aimed to work non-hierarchically, but the bitter irony was that we needed such a huge company, and to work on such a vast scale, that we realised with hindsight we'd developed a hierarchy ourselves.

JF: There's a tightrope between, on the one hand, an ego-centric fine art of a rarefied nature, and at the other end, if you're not careful, a sort of surrogate social work. We were hovering in the middle. We felt the work should be more open, more democratic, more participatory, but we weren't prepared to just do Disney look-alikes. We were making art that had a powerful image base, and it also had strong mystic qualities, and was accessible. It wasn't always simplistic or easy, but it was there in the public domain, and it often involved many, many people. We became more interested in that aspect of it over the years. I wrote *Eyes on Stalks* to pass on a lot of the tricks we'd learned about lanterns and fire pictures and big puppets; ideas come through you, you pass them on.

SG: We've seen artists pick up those techniques and knowledge about materials and go off and do amazing things, far more fabulous than we might have ever imagined. As well as the people who came through Welfare State who then started their own company, which is a lovely sort of family tree and legacy.

JF: By then, we felt we needed to have a more solid base. We settled in Ulverston and started the Lantern Festival here, which gradually grew and grew, and eventually set up Lanternhouse. For the first time we were all under one roof. The office, the music room, the kitchen, the library, some accommodation, rehearsal room, making, storage, everything. We'd gradually gotten a reputation, it was becoming an institution which we designed. But we were becoming managers, not artists.

IDEAS COME THROUGH YOU, YOU PASS THEM ON.

SG: Our public spaces were changing, with shopping precincts privately owned and everything. In all those early days, everyone was self-employed. But once we got that building, you had to kind of leave increasing amounts of yourself outside the door, and you're going, 'Oh, what have we done here?' Be careful what you wish for.

JF: By then, lots of people were doing similar work, possibly with a different motivation, but it was becoming more about the spectacle of it. We started to feel there was a different point, more to do with ecology, to do with rites of passage, helping people find art, making it where it was needed, at a crossroads in people's lives. How do you make a connection which is not patronising, is not didactic, is not sentimental, is not just a novelty? It's like the tip of an iceberg. We'd always done ceremonies within the company as we went along – if someone got married, or when there

was a baby the naming ceremony. Then, as you get older, more friends start dying and you go to horrific funerals that have nothing to do with them. So we wrote a book on funerals, and then a book on children's naming ceremonies. Sue took on the role of being a celebrant, doing rites of passage courses twice a year, for secular ceremonies, funerals, namings, leaving your job, you know.

THERE IS NO TYPICAL DAY. THERE'S NEVER BEEN A TYPICAL DAY, EVER.

SG: Funerals had been stuck in a Victorian mode: people sat there like rabbits and turned up to something that they couldn't recognise. Rites of passage are about people creating their own ceremonies, which is much more healing and the beginning of a bereavement or learning process, really. How do you celebrate, say, a single childless woman? What form would that take and what would it be about?

JF: We handed over the Lanternhouse building to other people. Then we started to work on Wildernest, which is a changing, outdoor work along the coastline here by our house. The style of art we're working on down here is a sort of sophisticated vernacular or folk style.

SG: It's a space for all kinds of gatherings. This is the Cumbrian coast: the main audience is dog walkers and hikers. We also do summer schools down there for artists. For us, it's about sense of place and a real commitment to this place, with its very distinctive qualities: the weather, the seasons and the

tides, but also oystercatchers and micro marine life. Learning how to make work in landscape is quite a subtle thing.

JF: We've been working towards a 'devotional space'. People need a framework to mould their lives around; It's offering a space of secular spirituality – if that isn't a paradox – where people could connect with themselves and the immediate landscape, connect with history, or marine life. Where you can feel at ease with an unfolding and changing pattern, which you're part of. I think that's in a way what religion does, but I think religion has become discredited. It's trying to find a language which people can relate to; the images are like triggers for visitors, to release creative energy or stories in themselves.

SG: There is no typical day. There's never been a typical day, ever. We still get invited to do projects internationally, as the Dead Good Guides. John has turned into the village signwriter. The next thing we're doing is a barn dance. Then we have the Fox Family Band that goes across three generations. As the oldest woman in the band, I play tenor sax and when we play in the street I can see women in the audience looking at me going, 'She's actually really old and she's playing the sax.' I'll go and talk to them and go, 'I didn't start doing this till I was forty, it's not difficult', and encourage them to try it. It's facilitating gatherings of people for whatever occasion, and trying to constantly be in a learning environment. We look to be surprised by things

JF: It's a question of what reality are you looking for? But it's also about where you place the art, and in what

context. In a way, the legacy of Welfare State has been the prototypes for living. Our family has become the most creative thing, in a way. I think we work through generations. Our generation has completely fucked up and left a bad legacy, and we've a big responsibility, but you can only really work on a hundred-year pattern. As the climate changes, kids are going to have to be flexible and to respond to whatever's around. It's terrifying, I think, for them. We need to find a new framework for connection, something else that people can be part of; and that's what we're essentially exploring.

SG: We've designed a biodegradable urn for ashes, for the cremated remains of a human, that could work with the tide coming in on the bay here. People always say to me, 'You've written this book on funerals and you do all this stuff, so what idea have you got yourself?' I said, 'I'd never thought I could bear the thought of being cremated, but actually it seems the only way to do this.'

JF: Mine is: you have a sieve that's got a picture on it, like the cocoa you dust on a cappuccino. You can spread the ashes with that, you know, have any image you want.

ELLY TAYLOR

Born 1930 in Amsterdam, Holland,
lives in Belfast

Taylor, who trained as a nurse, has been part of the community circus performance group Streetwise since 2013.

SELECTED PERFORMANCES

2019
Agewell Showcase, Ballymena

2017
Streetwise Gala, Belfast

2015
Streetwise Showcase, Belfast

My grandson picked up circus performance when he was in university, and his father started going along as well after retirement. Then my husband died and my son said, 'Come with me, that'll keep you doing things.' That was 2013. I was a nurse and I like gardening, using my hands and being outside, and I enjoyed the company, I enjoyed learning to juggle the rings, balls and clubs, and how to balance the flower sticks. I can roll up the Diablo, throw it in the air and catch it, which amazes me because I can hardly see the strings. I have glaucoma at the moment and a cataract, but I'll catch the thing and think, one up for me!

I'm not really a performer. I like to be in the back somewhere, somewhere comfortably in the middle so that you don't notice me. But I enjoy the doing of it and if I get better at it, then I know I've learned something. It's a personal goal; like juggling three balls at once, I've been trying for the past seven years and I still can't do it, but you don't give up on something you try. But maybe, with perseverance and just sheer cursedness, I'll get there one time. Mostly it's fumbling around: with the clubs I either throw them too far or not far enough, but can't seem to catch them at the right point. I'm either too quick or too enthusiastic. But some people can just do it quite calmly, throwing four or five at a time to each other. I don't have to be able to do everything, some people are just better at it than others. But it's fun watching. They

say if you've got a maths brain, you can do certain things better than others, I haven't got that kind of brain. If you can use your hands, I think sometimes you don't need your brain, really. Between the two, I'd rather have my hands.

I'm from Holland, and was raised in Montessori schools my whole life. Every class had their own gardening plots that they looked after. It had a sense of freedom and movement, but also emphased that you can't learn anything without trying. My father was a journalist, and worked with the Dutch resistance during World War Two. He always said, 'There are so many of us' — we were five children at home, so seven of us — 'You're all different. As long as you get on together that's fine. You can have your differences. Talk it out. Be done with it.' After the war, I came to England for a year as an au pair, and then came back to study nursing. I mean if you're in a brilliant place, you don't want to leave, do you? Then I met my husband, and he was from Belfast and he really wanted to keep an eye on his widowed mother. So we came here, and I like it here.

The community circus is great, because it puts everybody on the same level. Anyone can come along – no one needs to be a stranger. I've been there, I didn't know anybody when I first came here. We'll start off each session in a circle: you throw a ball to somebody and that somebody throws to somebody else, and you have to try and remember who you throw it to and who you get it from. You might get about seven balls going at the same time. You can't wander off because then you miss the ball, and then you upset the whole thing. If you can do it for three times without anybody dropping a ball, it's time for a cup of coffee. Then you get on

with practising the things you want to do; you find your own pace, and it has a sense of playfulness I love.

Circus performance doesn't suit everybody – some prefer to do knitting, I used to sew quite a bit. Everybody to their own. But it's good to keep moving, it keeps you alert, to mix with people, and it gets you doing something you couldn't do before. You don't have to become an expert. You can try, and if you like it, then you can do more of it. I always start with the three balls because I'm determined to get it right. I haven't mastered it yet, but I will do one day. And then I'll have to learn something else.

RASHEED ARAEEN

*Born 1935 in Karachi, Pakistan,
lives in London*

Araeen is an artist, writer and curator,
who works with sculpture, drawing
and painting. In 1978, he founded
the publication *Black Phoenix*, and in
1987 founded the influential journal
Third Text.

SELECTED EXHIBITIONS

2019 **Garage Museum of
Contemporary Art**, Moscow

2018 **BALTIC Centre for
Contemporary Art**, Gateshead

2017 **Van Abbe Museum**,
Netherlands

2014 **Sharjah Art Foundation Art
Spaces**, United Arab Emirates

2013 **Tate Modern**

1994 **South London Gallery**

1989 (curator) *The Other Story: Afro-
Asian Artists in Post-War Britain*,
Hayward Gallery, London

1988 (curator) *Essential Black Art*,
Chisenhale Gallery, London

1988 **The Showroom**, London

SELECTED PUBLICATIONS

2010 *Art Beyond Art: Ecoaesthetics*
(Third Text)

1984 *Making Myself Visible*
(Third Text)

I never wanted to be an artist. My ambition was for architecture. But there was no architecture at the school in Karachi, so I went into engineering with the hope that that would lead me to architecture. I had always been interested in drawing as well, and I joined the two art clubs in Karachi to practise and improve. I began to do watercolours, and in the late fifties I hit on the idea of using more abstract imagery. That was the beginning of an idea of what I should pursue; I began to have doubts about a career as an engineer. And I decided in favour of art.

We had no art venues in Karachi. Even now, we don't have a museum there. So it was difficult to be able to imagine yourself as an artist. I continued to study engineering, while I carried on with my work as an artist at home, with the hope to leave the country to have more opportunity elsewhere. I got to London in 1964, and to survive I got a job as an engineering architectural assistant with British Petroleum. Meanwhile, I was making myself familiar with the art scene in London, and I came across the sculptures of Anthony Caro. I was so fascinated I decided to abandon painting. I became very interested in sculpture, but I had no means to create it: you need a studio, you need materials, you need skill. I'd never learned it. It was a bit of a dilemma. I couldn't make it, but I couldn't stop thinking about it.

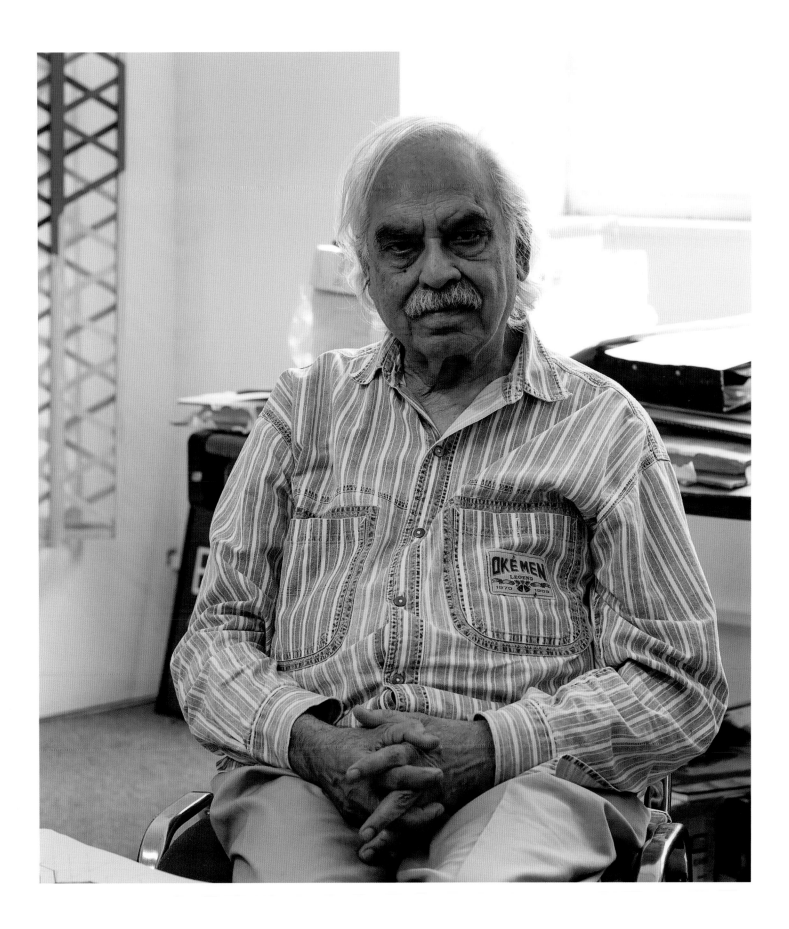

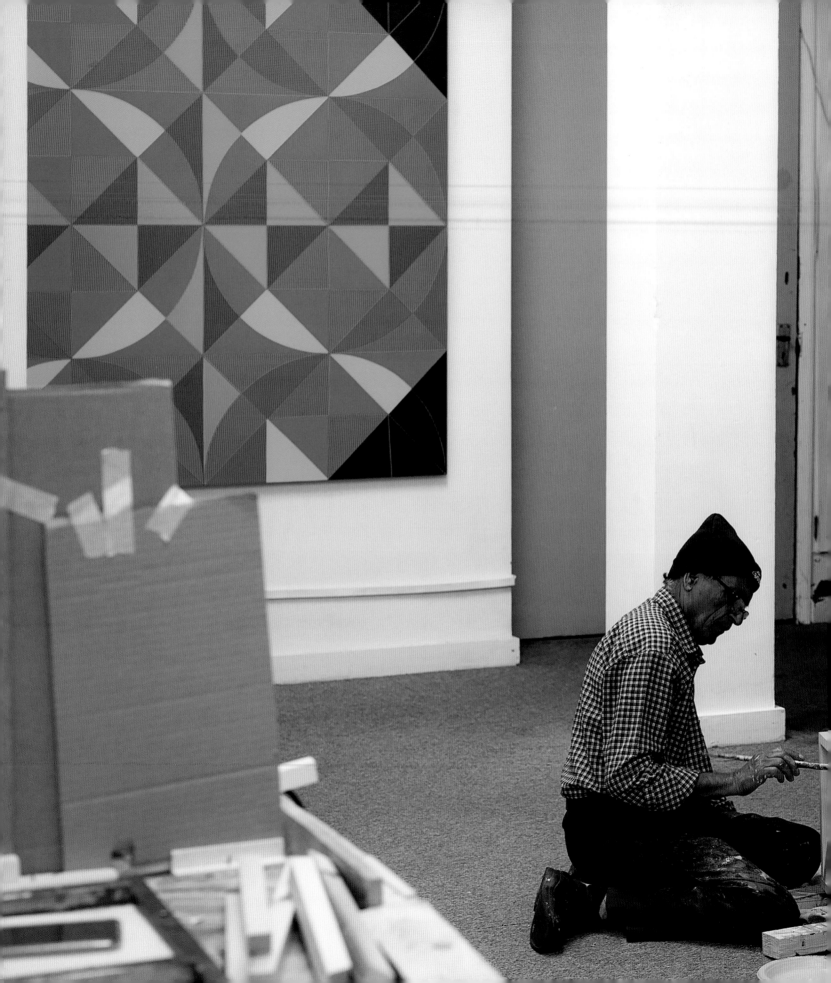

I began to develop ideas of the kind of artwork that I wanted to make, made up of cubes and symmetrical geometry, and I kept on thinking, 'How could I make them?' I discovered a DIY shop with wooden strips that would work, and I began making small maquettes on the kitchen table in my house, and it went from there. Eventually I left my job, and got a studio that I went to every day, all the while hoping I would get a gallery to show my work. But I couldn't. Everywhere I went the response was, 'No, sorry, we are full.' I was a bit baffled; then I had a friend who talked about the nature of society, racism and anti-colonial struggle. I began to read

Franz Fanon, I joined Black Panthers. These were the things that led me to into writing, led to campaigning for other artists, and led me to organising the exhibition of Afro Asian artists at the Hayward. It was a very complex life, with different levels: writing, thinking, making art, performing. At the same time, bashing your head on the establishment. It was difficult, particularly when you didn't have resources.

I started to think, why should I keep on banging my head against the brick wall of the British establishment? Maybe I can bypass it. I had always struggled against that idea that what I was producing was Islamic – my main inspiration was Modernist art. It wasn't important to declare myself as Pakistani or Muslim. Why? But the war in Iraq, and the whole diatribe against the Muslim community in Britain coming from politicians and the media made me think about my identity. I began to read about Islamic civilisation, and I went back to Karachi and set up a studio there as well. I began to make calligraphic work invoking the achievements of Islam, using the names of important thinkers like Avicenna and Averroes.

For decades, I was known more as an activist, as an editor, as a writer. I had no career as an artist until recently, when I had a show in Sharjah in 2014 and it opened the way to more exhibitions internationally. There was a big gap when I didn't do anything, except thinking. I had destroyed most of my old sculptures. Now I'm reconstructing them. I can't paint big works because of my physical condition – I'm in my eighties, and suffer from motor neurone disease. But I'll produce detailed sketches, and my assistants will enlarge them and make the painting.

There are multi-layered sources of inspiration behind each artwork. There are Islamic geometric patterns, and the Russian artists of the early twentieth century like Malevich, but also things like the black-and-white floor tiles of my house here in London. It becomes a complex meditation on geometry. I've also begun to bring my painting work and sculpture work together. I've opened a restaurant in north London, which is an artwork. It's like a living room, with simple, nourishing food. I wanted to bring art into life. We should be thinking more about art beyond showing it in galleries and museums; once it ends up in the museums, it is cut off from the life. With the restaurant, I provide the structure, then the audience themselves make whatever they want from it. All of the profits are put into tangible projects in Africa. My plan is to reclaim land from the desert, and set up a collective of organic farming. That is my ultimate aim.

FORGET STYLE

Sitting in Ralph Steadman's ink-splattered barn studio in Kent, I asked if he might have anything that could be taken as 'advice'. He immediately answered, 'Forget style. It's a pain in the ass. It gets in the way of what you're trying to do.' I thought the remark strange, coming from an illustrator whose work is instantly recognisable. But I realised, as we continued to speak, that for him 'style' didn't mean how something appears, but a more internal quality, part of the artist's decision-making process. Several other people described a similar sentiment: that you should prepare, and prepare thoroughly, but after that, you can't decide what something is going to be before it exists, so just let it go.

It reminded me of a quote attributed to the saxophonist Charlie Parker: 'Learn your instrument. Then, you practise, practise, practise. And then, when you finally get up there on the bandstand, forget all that and just wail.' While the artists gathered here have practised, practised, practised in fine art, traditional Indian dance, Zen Buddhism, or even the demands of producing cartoons for daily newspapers, they can now rely on this background to release themselves to making their art. This chapter is dedicated to the art of un-knowing, of forgetting the things that hold you back, and just playing.

RALPH STEADMAN

Born 1936 in Wallasey, lives in Maidstone

Steadman is an artist and illustrator, who has contributed countless caricatures and cartoons to publications such as the *New Stateman*, *Punch*, *Private Eye* and *Rolling Stone*, and has illustrated the works of James Joyce and Lewis Carroll among others.

SELECTED PUBLICATIONS

2017 with Ceri Levy,
 Critical Critters (Bloomsbury)

2012 with Ceri Levy,
 Extinct Boids (Bloomsbury)

1994 *Teddy! Where Are You?*
 (Andersen Press)

1998 *The Big I Am* (Jonathan Cape)

1986 *Paranoids* (Harrap)

1983 *I, Leonardo* (Jonathan Cape)

1979 *Sigmund Freud*
 (Editions Aubier)

1973
 Lewis Carroll, *Alice in Wonderland
 Illustrated by Ralph Steadman*
 (Clarkson N. Potter)

1972 Hunter S. Thompson, *Fear and
 Loathing in Las Vegas*
 (Random House)

1969 *Still Life with Raspberry*
 (Rapp & Whiting)

The main thing of all my drawing has always been to get to the nitty gritty of everything. But it's not where you think it is. It's like for the book I did on Sigmund Freud: I went to Vienna, ninth district, to find the house where he had lived. Downstairs in the cellar was his consulting room, it still had the original wallpaper on the wall. I laid down where the couch was, and did drawings of the angles of the ceiling. Things like that had to be in the book. Or say when I went to New York in the seventies, I felt I had to draw the homelessness I saw. I've always been interested in rough sleepers – the exacerbation, the hardship, the bitterness, the sheer hypocritical nature of life. It's terrible. It's the side issues, the accidents, the mistakes that are the real issues.

I always built model airplanes as a child, and what I wanted to do more than anything else was to become an aircraft engineer. So I left school and got an apprenticeship at an aircraft company factory in Chester, and it was alright for a while. Then I suddenly felt, 'Uh, I can't stand the bloody idea of coming here every day.' I got a job at Woolworth's as a trainee manager, or actually a stockroom boy. I really didn't like it. Every Friday night, I had to sweep the floors then oil them, until I had to do my National Service. While I was there, I came across an advert, quite by chance, that said, 'You too can learn to draw £££.' So while I was in military service, I did the Percy V. Bradshaw Press Art School correspondence course in 'How to Draw' and then 'How to be a Cartoonist'. It kept things going.

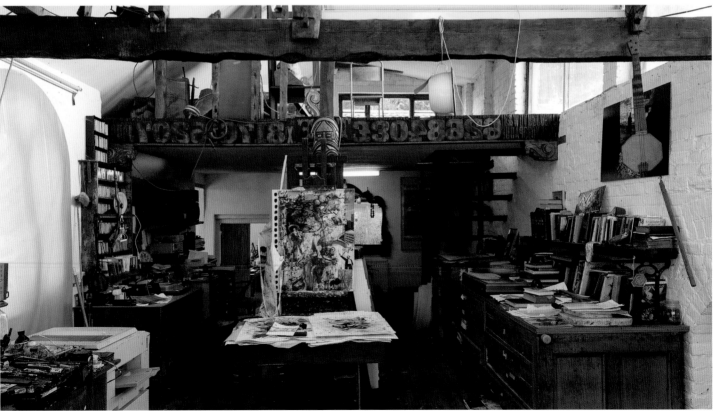

I got an offer to be a cartoonist in the art department of a newspaper syndicate – my first cartoon appeared in the Manchester Evening Chronicle in 1956. It was during the Suez Crisis, and it was a Giles-like drawing of a lock keeper, saying, 'Nasser? Who's he?' I was doing these cartoons every day, single-image cartoons, like a man and a woman are in bed, looking up and the roof's gone, and the man says, 'I had an awful dream last night.' Things like that. The newspaper moved me down to Fleet Street in London, where I was given a drawing board in the entrance office, so people would be passing by constantly while I'm trying to do a drawing. It was quite nice because I met a few people that way, and I started working with *Private Eye*, the *New Statesman* and *Punch*, and went freelance. I was also going to afternoon art classes at the same time. Myself and the illustrator Gerald Scarfe would go to the Victoria & Albert Museum's machine room, or the Natural History Museum, and we'd sit and draw objects and people for hours. I used to get these rejection slips from cartoons I'd sent to magazines, 'Sorry, not quite,' all the time, but having tried all these different odd jobs, I just knew that this is what I wanted to do.

I was staying with friends in New York when I was rung up by a guy: 'How'd you like to go to the Kentucky Derby and meet an ex-Hell's Angel who just shaved his head?' That's when I met the writer Hunter S. Thompson. There was some other cartoonist he had wanted to go with him, but that cartoonist was on his way to England, which is funny to think how easily we wouldn't have met. They wanted the faces of the people at the races, not the horses, so I took a camera, taking pictures from the hip of the expressions in the crowds while the races were going on. Thompson became a kind of strange friend, working together on articles and books over the years. My work had already been shifting, but our relationship helped bring something else out, helped release the subconscious beasts.

THERE'S NO PROPER WAY, OR RULE ONE, RULE TWO, RULE THREE. IT'S NOT A STYLE, IT'S JUST HOW I GO.

I don't know what I want when I draw. That's the whole point of doing these things, putting them down and seeing what they look like. Because what you're doing, you're putting something down that wasn't there before. The worst thing is it becoming just a job of work and not something far more. When you've done something and you're really thrilled with it, that's worthwhile. So the best thing is to chuck some muck about, really.

There's no such thing as a mistake. A mistake is an opportunity to do something else, which is what this is all about. There's no proper way, or rule one, rule two, rule three. It's not a style, it's just how I go. Forget style, it just gets in the way of what it is you're trying to do. So if I make a mistake in the process, I'll make it work. And making it work is part of the enjoyment of it. I never do pencil first, I go straight in with it in ink. With pencils, you have to then transfer it, and you're then carefully trying to do something, and you lose your verve in the thing. There's

something more interesting about a mark. Not a mark of intent but an accidental happening. It mixes things up, something just happens.

For ideas, I quite like poetry from time to time. Funnily enough, I've just read a book about Mote Park here in Maidenhead, about the things they've done there through World War Two. I'm far more interested in books about real places or real people than I am about reading, oh, James Joyce, even though I've illustrated Joyce.

I'll come in to the studio and I'll just throw some dirty ink water down. I just make a mess, and then see what emerges out of it, and if it turns into something. The dirtier the water, the more interesting when it dries because the textures you get in the thing are extraordinary. Now, I couldn't draw that. I'm letting nature do it. I'll add some coloured ink onto it, so then it does something that I can't do on my own. It's a process that feels like it happens on its own, as if I don't have to do anything with it. I can't draw, actually. It's just welcoming accident as part of your working process, a kind of part-guided version of accident. I am my own accident.

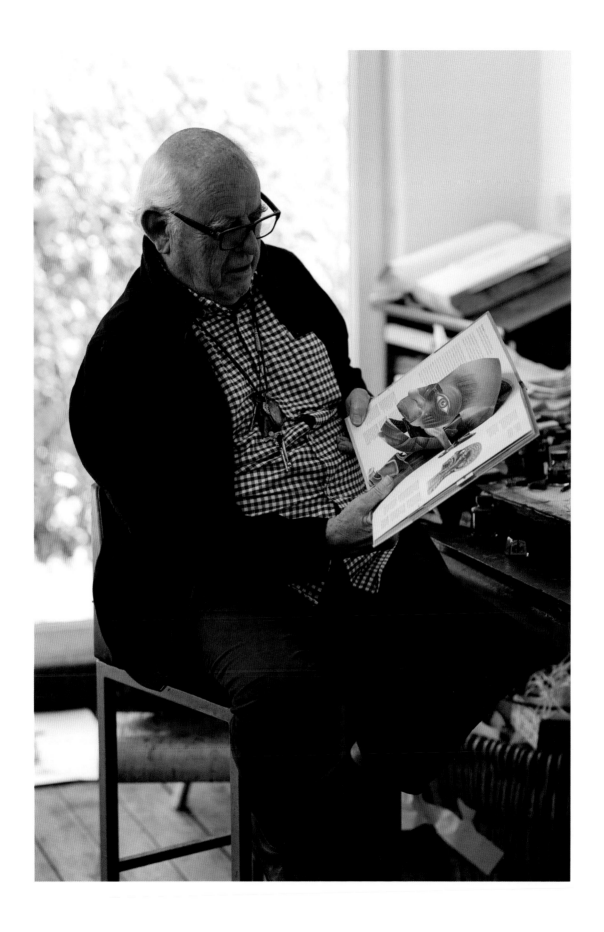

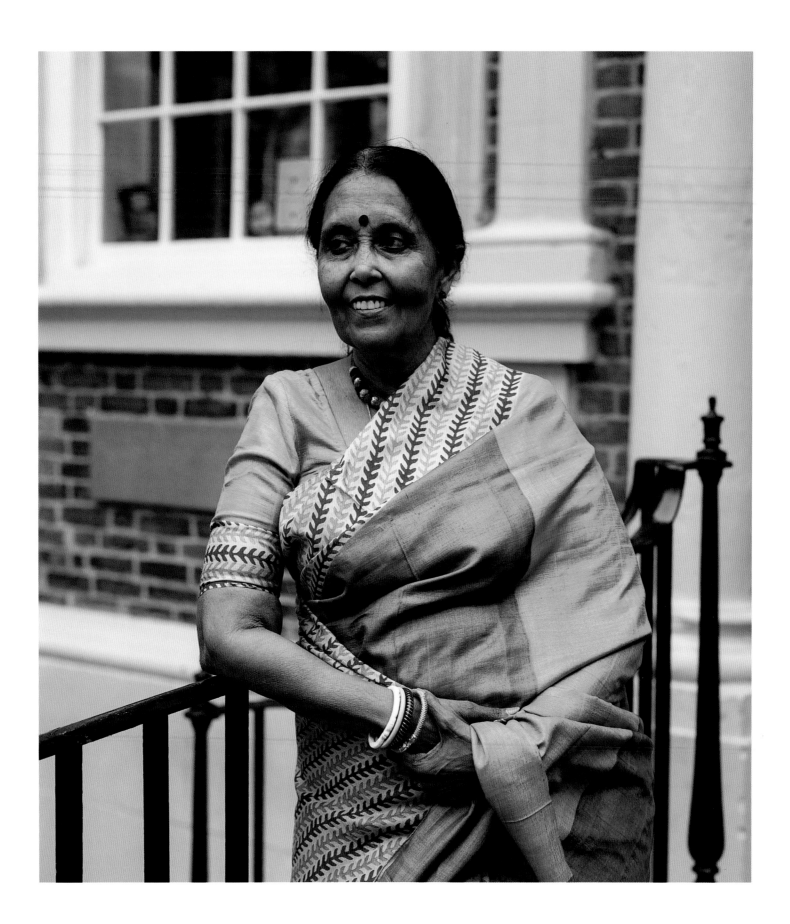

BISAKHA SARKAR

Born 1944 in Kolkata, India, lives in Liverpool

Sarkar is a dancer, choreographer, and facilitator. Trained in classical and creative Indian dance, she has performed and led countless workshops and conferences across the UK. She is the founder of the Chaturangan Dance Company.

SELECTED PERFORMANCES

2013
Fleeting Moments, Liverpool

2006
Two Pots, Liverpool

2005
Dance of the Night Sky, Liverpool

2004
Sacred Moves, Liverpool

1996
Tending the Fire, UK tour

1985
Chitrangada, UK tour

SELECTED EXHIBITIONS

2015
Do not yet fold your wings, Liverpool

A long time back, in an artist's workshop, somebody said, 'Tell us one thing that drives you to do this sort of work.' I remember I said: family. Having left a family of friends and a community back in India, I had an urge to create a new family and friends here in the UK. And that's why, perhaps, I have taken the route that I have.

In India, I had studied statistics; I also trained in dance, but it was something I did for enjoyment. I came to England as an adult, with an idea of working as a statistician. I found it was quite a different England from what I had imagined, I thought it would be a lot less traditional. Then I had a child, and that changed my lifestyle, having to do all kinds of housework and managing everything. Since then, my dancing career has always run in parallel with domesticity. I didn't drive in those days, and I didn't really know many people, so I used to bring my little girl into the city centre. One day, I walked through an archway to a garden, and I immediately fell in love with it. I thought it was my hidden garden. Then I looked around, it was the Bluecoat arts centre, so I found the offices and introduced myself, telling them that I dance and if they have any events to let me know. Around the same time, I found out about a garden party that was happening in connection with the English-Speaking Union, so I contacted the organisers and asked them to give me an opportunity to dance. They agreed – that was the first time I danced

in Liverpool. Through things like that, I got to know a few people, and one thing led on to another.

I didn't really know any other Indian dancers in Liverpool around that time, in the early seventies. I would do things for the Indian community, in temples or community halls, and then I began to offer workshops and later I was invited to be part of the Bluecoat's advisory panel for dance, I believe I was their first non-white panel member. That's where I got to know about the dance field around the city and the north west, and to get opportunities to take part in dance events and performances.

EACH OF US HAVE TO EMBRACE NEW FORMS OF TRADITION. WE MAKE TOMORROWS, AND TOMORROW THEY WILL BECOME PAST.

In this country, if I wanted to dance I could not restrict myself to just dancing on professional stages. I went to all sorts of different places: community centres, day centres, old people's homes. It was a huge challenge to work with communities who might have never even seen Indian dance. People have said that the work that I have done has bridged the gap between cultures. I don't like the word 'bridge', which always means there is a separation. I try to delve to the riverbed, if you like, to find things which are of common interest. That was a big shift for me in my thoughts on dancing, focusing not on the technical skill of my traditional training, but on finding ways to really

communicate with people, to feel that we are all going through a single journey.

If something is alive, then it changes. You need to be rooted, but to grow you also need your branches, which breathe the air of the moment, and take in the sunshine of the place where you stand. You have to have a balance between what's traditional and how far you are prepared to move with time. The places you perform, people you perform with, your own understanding, the way you look at the world, your connections are all relevant; I allow all of those to influence me. Tradition is being made all the time. You don't have to be too precious and think of tradition as something that cannot change. Each of us have to embrace new forms of tradition. We make tomorrows, and tomorrow they will become past. In my life I've met so many wonderful people of all ages just by doing this work. I found a kind of new person in me, and it is all of those encounters that have made me who I am today.

Most of my dancing, in those days, was through teaching. I started working with young children, doing projects in schools, learning how to find the language to connect with them. I would do the movements, and they would find their own ways to describe them: like the washing machine, the wipers on the car. It was a way of giving them some of the power, to imagine and make their own connections in their minds. Around that time, I was working for an insurance company and I was asked by a colleague to dance at a fundraiser for guide dogs. That was a turning point in my life. I thought, I'll be dancing to help people with visual impairment, but I'll be doing something that may not

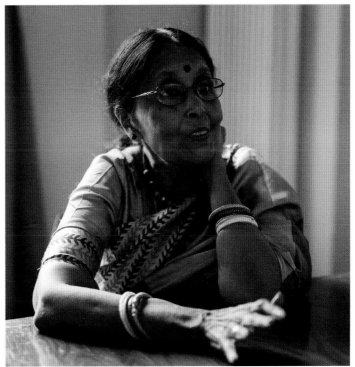

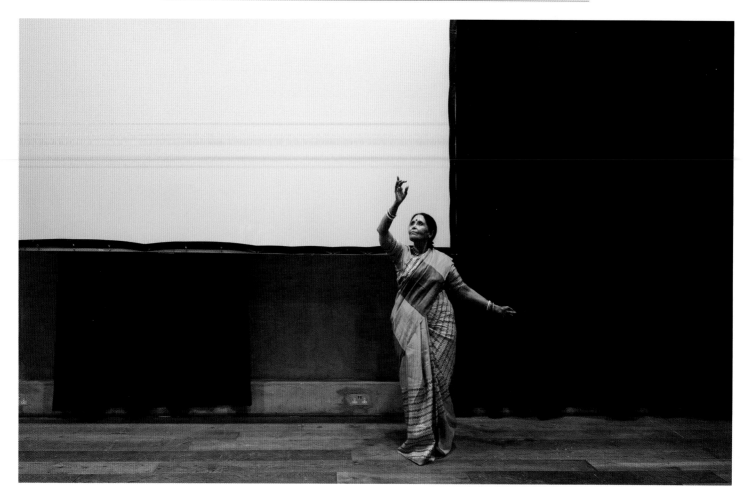

be accessible to people with visual impairment. It really bothered me. How can I exclude the very people that I'm meant to be helping? I really had no training in this field, I didn't know what to do. This led me towards my work with dance and disability, involving people with a range of physical disabilities and learning difficulties. I started by thinking about extra-visual and integrated dance.

What dance is, really, is an engagement with energy. You can put your arm in a straight line or a curved shape, and allow the energy to flow along that. As you move, your relationship with gravity keeps changing. So for me, dance is a play of energy. For visually impaired people, I tried to create

movement motifs that could work like building blocks, things I could teach to help them to imagine a dance. Using music and the emotions that it gives internally, people can create their own imaginary dances and join as I dance with them.

Throughout my life I've tried to keep my performing career going parallel to my role as a community dance facilitator; I don't see a separation between the two. In the early eighties, I worked for Merseyside Arts as their first Asian dance 'animateur' outside London, to make Indian dance accessible to a wider community. This gave me the chance to use dance in a creative way in all kinds of situations, both in education and in the community. At the same time I met

a fellow dancer, Sanjeevini Dutta, and formed Sanchari Dance company. We produced and toured many new style performances all over the country, as well as making teaching resources. Eventually, I set up my own dance company, Chaturangan, creating new dance productions, supporting artists to make new work and organising conferences on topical issues.

I don't practise every day, not really. But I do dance every day: every morning I like to settle myself, doing a dance as a prayer. Otherwise I just dance whenever there is an opportunity to dance. My dance pieces don't start with any fixed, clear idea. Some choreographers see the image right from the beginning. I'll get an idea and I'll desperately want to do something with it – I can sense it taking shape, but what it is, I don't know. Just believe that it will come. I think you have to have an open mind, and not have one fixed idea. I have to remain sincere in my attempt to do what I do.

I'll get an idea that inspires me, it could be from a photograph, or an email. I want to communicate it, I want to say it straight out. That's the starting point. Then I'll bring other people together to discuss things, and share our lives' experiences. Recently I had knee replacements, and I wasn't moving much. But the brain needed to dance even if the body could not do much. I went along to a gallery just to do something in the afternoon, where they were announcing the name of an artist working with the CERN lab in Switzerland. It really shook me to learn about the lab and the hidden quantum world, I came out of the gallery all excited. I wanted to create something, to share a layman's excitement about that world. I don't want to talk about

science, because any scientist can talk about that better than me. But dancers speak in their own way, with their own kind of intelligence. I can show an artist's excitement for an idea, an artist's translation of an idea. So a few of us who often work as a team – a visual artist, a musician, a poet, an illustrator and a dancer – put something together, and presented it at the planetarium. I trust a group of people that I've been working with to pull their own thoughts together, to bring new ideas and think for themselves. That's how a work grows. It's a gesture of sharing, to create a bigger picture. All those things create layer upon layer, and the more layers you have the richer the work gets. Every movement becomes more meaningful. There are huge chunks of moments of uncertainty, when you think it will not come together. It just needs everybody's trust, you know?

DANCERS SPEAK IN THEIR OWN WAY, WITH THEIR OWN KIND OF INTELLIGENCE.

You cannot respond to every issue that catches your attention. But I think every artist has got a responsibility. Your purpose of life in every way is to respond to the world around you. As an artist, you just do that in a slightly different way, by communicating your feelings, often reaching out to unknown people. That desire to reach out, to connect, to share your own feelings, is what I try to do, and that's what keeps me going.

MARIAN SANDHAM

Born 1945 in Sheffield,
lives in Rhostryfan, Gwynedd

Sandham is an artist, and a community art teacher with Age Cymru.

SELECTED EXHIBITIONS

2008
Caernarfon Library, Gwynedd

2005
Conway Centre, Anglesey

2004
Cerrig yr Afon, Y Felinheli

I feel funny saying I'm an artist, but I've always drawn and painted since I was very small. If it's there, it stays there. I think about art all the time. I used to work as a legal secretary, and when I retired at fifty-five I did a bachelor's degree in Fine Art. I waited so long to do it, but I think I had more to bring to the table because of life experience. You're more confident the older you get, you can express yourself better. I enjoyed every single minute of studying art, it's the only time I was ever able to devote to focus on my creative side on a daily basis.

With art, I don't like anything that's really neat because I'm not a really neat person. I like painting something that moves and breathes, especially animals. Nature is my main inspiration. I've got beautiful horses in the field just outside my window here, so I paint them a lot. Our views out over the coast are amazing, we get fantastic sunsets here. But I don't do landscapes. Everybody says, 'Oh, I bet you're out here painting all the time.' Oh gosh, no! Maybe once every three weeks! Between domesticity, grandchildren, cooking and so on. I can't make myself come up to my studio. I couldn't, after doing a meal and the washing, come up here and think, 'Right, I'm going to paint now.' I have to do it first thing in the morning and shut myself off up here. I've got to put some music on and just blank everything out and go with it. Then I can just go into my own little space. I don't want to know about the washing or what's for dinner or who's coming for this or that.

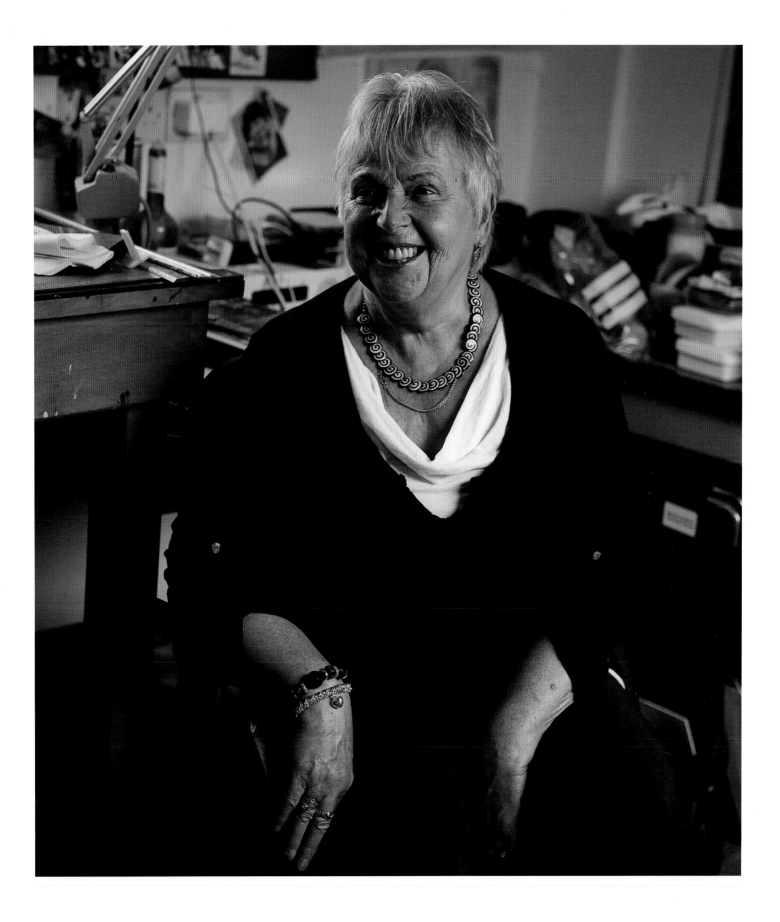

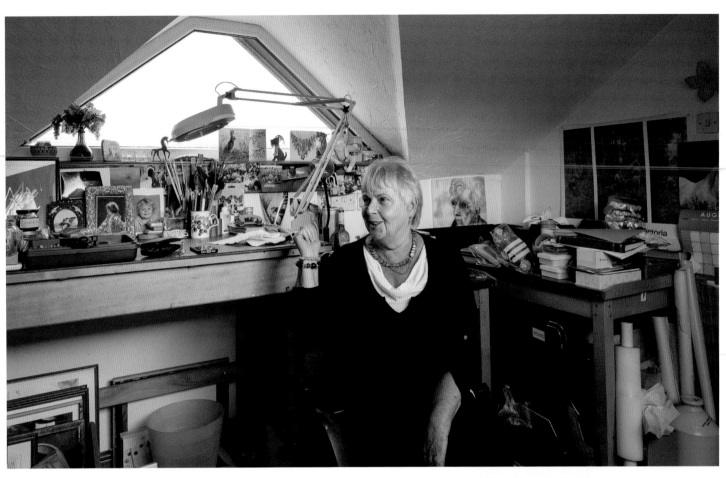

I have my studio upstairs in our house, and then a small gallery set up next door, so that people can come see the work if they want to. When you go to the gallery, it doesn't look like one person's body of work. It's very eclectic. I experiment, working with a range of things depending on what I've encountered and what I've noticed. Ink and bleach, watercolour, acrylics. I do lots of collage, and I've been incorporating paintings on book covers. I like doing multiples: if a piece is going well, I'll probably do a few different variations on a theme. Some of the paintings tell a story, but of course somebody might read something else totally different into it.

Studying art certainly shifted my approach: it taught me the confidence to use different mediums, and I've learned how to look. The artist Peter Prendergast was one of our tutors, he painted in an absolute frenzy. He taught me how to look at things. Once you see where the light is coming from, things become more alive. That was the best thing I ever learnt. That's what I try to give to my students: try to see the light.

I love working with people who might say, 'Oh, I can't do this, it's too hard.' I think I could get most people to paint, and make them feel good about themselves. You've got to make them feel that it's no big deal: just put some splashes down and get going. Once it's started, it works. The people who come to my arts and crafts group are all at different levels, and want to do different things. But as a group, we're there to support each other, and being in that environment where people are creative, you feed off each other and it's fantastic. I help them to see just what few little things they could change, and often they're surprised. I can get more out of them than they think they're capable of.

TO GIVE SOMETHING OF YOU IN A PIECE OF WORK MAKES IT A PIECE OF ART, TO ME. THAT MAKES IT DIFFERENT, AND THAT MEANS THERE'S NOTHING ELSE ON THE EARTH LIKE IT.

You don't make art to please anybody else, or to sell anything. If it's a passion, it's with you all the time. It gives you something to think about, it's something to excite you. It sustains you: it's nutritional. At the college, they always said, 'Don't do what somebody else has done.' To give something of you in a piece of work makes it a piece of art, to me. That makes it different, and that means there's nothing else on the earth like it. So I strive to be a little bit different.

ALASTAIR MACLENNAN

Born 1943, Blair Atholl, Perthshire,
lives in Belfast

MacLennan is an artist who works with performance and live art. He taught at Ulster Polytechnic/Ulster University for thirty-four years. He was a founding member of Belfast's Art and Research Exchange, is a member of Black Market International and co-founded the international performance art organisation Bbeyond.

SELECTED EXHIBITIONS

2017
 with Sandra Johnston,
 Edinburgh Festival

2015
 Do Disturb Festival,
 Palais De Tokyo, Paris

2003
 Ormeau Baths Gallery,
 Belfast

1997
 Irish Pavilion, Venice Biennale

2004
 Cerrig yr Afon, Y Felinheli

2003
 Knot Naught (Ormeau Baths)

1988
 Is No: 1975-1988 (Arnolfini)

My mother's folk are from the Isle of Skye in the northwest of Scotland and we'd go up for a couple of weeks to visit during summer holidays. They lived in an old white house overlooking ageless moors. There were no trees and only three or four houses in the whole valley. I remember as a very young child being in awe at 360 degrees of raw nature. It was so ancient and primal a feeling, with ocean soundings and ghostly echoes of sheep miles away over an infinitely old moor. It seemed before the beginning of time. I recall being outside the house and sensing timelessness inside me as well as outside. You were immersed in it. I didn't have language to talk about this, then. It's affected me ever since.

I studied Fine Art at what was then a very traditional art college in Dundee. Before we were allowed to draw from actual models we had to learn human anatomy: skeleton structure, muscle fibres, all the way up to skin and surface appearance. It was very figuratively based, about how structures appear to the naked eye. I was relatively skilled at representing this and knew I could spend the rest of my life painting portraits, but felt this was incredibly limiting. I didn't want to be able, when I was twenty-one, to imagine and know what my practice would be for the next forty years

Shortly after leaving college I was resident art teacher at a summer camp for very young children. I was amazed

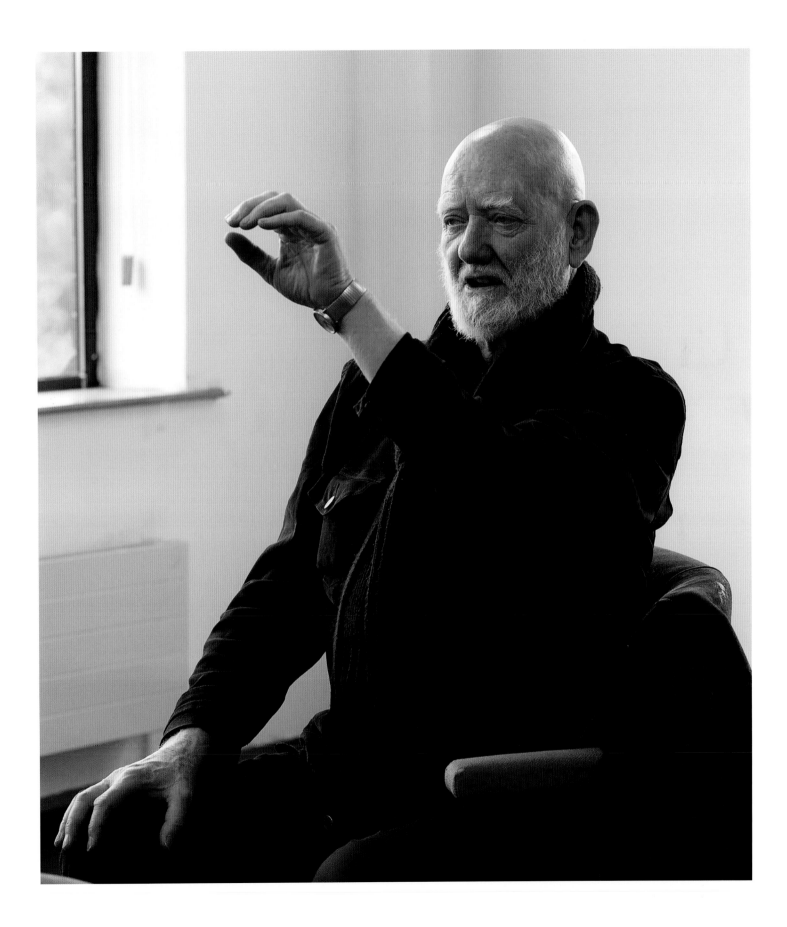

by the art of these kids. As students we'd learned to treat paintings as objects you were detached and separate from. You would judge them as things. But there was a disarming purity, an intrinsic beauty in how and what the children made. They worked from the inside out, not just from surface appearance. After class I'd look at their work and at my own, thinking 'There's more purity in their art than mine.' I loved painting, but how could I, as an adult, paint from the inside out, not just from surface appearance? When I tried to do it, past training interfered and I'd self-edit.

Then I got a fellowship to do a Masters in Chicago, in the United States. In the studios students were from different countries and backgrounds. Everyone was making different kinds of art, more diverse than Dundee had been. I began to feel, 'What's the point of communicating something well, if I haven't anything worth saying?' I began painting mechanical objects, applying paint in an impersonal, mechanical way. I said at one point to my teachers, 'I'd love to call an empty section of corridor, near our studios, an artwork. As it's empty, you wouldn't be able to experience content with any of the senses. But somehow, you'd be aware it was full.' We laughed about it as an improbable idea. I mentioned this later to an older student friend and she said, 'That sounds a bit like Zen.' I asked, 'What's that?' She replied, 'Something to do with fullness of emptiness and emptiness of fullness.' I was intrigued, so started reading up on Zen.

I didn't agree with the Vietnam War at the time, so some time after graduating, to avoid having to enlist in the American army, I went to Canada and later got a job teaching in the Nova Scotia College of Art. It was very open and experimental there. At weekends I tested things out in the surrounding landscape. By the seashore I'd balance a large egg-shaped rock I found at Scot's Bay on my head, while I'd look out to sea to locate the farthest away wave I could focus on. Keeping the rock balanced, I'd follow the wave as it came, all the way into shore, to dissolve at my feet. I'd do things like that to focus mental attention. There was a university very close behind the art college and I went there one day and stood in the cafeteria behind a large block of ice I'd brought, intending to stand motionless, in performance mode, until the ice melted. But I'd no idea how long it would take for the ice block to actually melt. So I had to stand there for hours, motionless, for a seeming eternity. That, perhaps, was one of the ways I got into doing longer performances.

Later, I decided to move to Vancouver, on the other side of Canada, to explore Zen more deeply. I went to a Sesshin, a Zen retreat where the Zen Master set me a koan, a problem to solve: 'How do you realise your true nature while painting?' Then you'd go meditate and have several interviews a day, to manifest your answer. You needed to answer palpably, physically, as he'd accept no verbal response. Initially he said, 'Nah, not a real artist,' and gave me another koan to work on. I thought, 'If I can't answer this painting koan, I'm a fake.' So I stopped seeing art friends and took a job washing dishes in a downtown restaurant, so I could focus on the art koan while working. One night, while working, the problem

dissolved. The answer, as such, was in realising there was no separation between artist and artwork. An artwork might indeed ensue, but it would be simply as a result of giving total attention to the art-making process, moment by moment as one's engaged in it. I went to the next Sesshin and the Master passed my koan response successfully.

IF ANYONE HAD TOLD ME AS A STUDENT I'D COME TO PERFORMANCE, I'D HAVE THOUGHT IT ABSURD. BUT YOU DON'T COME TO REALISATION UNTIL RIPE FOR IT.

After that, I felt I could make art in any situation. It has to do with how you interfuse with whatever situation you're in. For performance art, you have to be totally present; you're using your body as art material, as paint and paintbrush. If anyone had told me, as a student doing academic, figurative painting, I'd come to performance, merging the how and what of art making, I'd have thought it absurd. But you don't come to realisation until ripe for it.

There's a phrase we hear in Ireland: 'same difference'. There's sameness in difference and difference in sameness. If we tap into difference, we find units of commonality which can be used constructively and avoid getting caught in binary traps. I found it interesting coming to Belfast nearly forty-four years ago. It was very much the early time of the political Troubles here, and students from different backgrounds in Belfast wouldn't have met each other until

they first came to the art college. I told them back then, I'm neither Unionist nor Republican. I'm not for 'either-or', I'm for 'both-and'. A problematic situation can suggest ways to transition or transform it, so sometimes I use negatives to try to change how we 'see' a situation. Often, if we have a problem, the solution's right there in front of us, but most of the time, even though looking at it, we don't see it.

WHEN WE LOOK CLOSELY, WE CAN NOTICE CERTAIN THINGS IN A WAY WE MIGHT OTHERWISE NOT PAY ATTENTION TO; TINY LITTLE THINGS BECOMING MUCH MORE IMPORTANT.

My studio is a preparatory test ground. Before art making, I meditate, then do drawing actions on paper as a kind of ritual. I've always been intrigued, even when young, with a

blank page or canvas. To me, they're metaphors of infinity. Any image can manifest on a page, any form may come out of it, any image could recede into it. It's like the tissue I have in my pocket: the whole notion of the infinite, of the blank, pure page and its past, present and potential future, is also within it. I may use something as simple as blank tissue as subject matter.

I sometimes use the *I Ching* (the *Book of Changes*) as a device for making decisions. If I have an idea, there could be umpteen variations as to which would be the most appropriate way to realise it. I may use the *I Ching* as a mental mirror or detached way to make chance decisions: it might be the fifteenth possible variation, or it could be the thirty-second. I continually try to surprise myself. But, in spite of that, if intuitively I'm not happy with the result, I tear it up. I've a box under a studio table full of torn-up works on paper. Ultimately, though, primal instinct and intuition carry the day.

Very often, ideas start with something I notice, possibly outside by the roadside. When something's a bit awkward, or not quite working, I'm intrigued by the not-quite aspect and try to suss what makes it so. I'm fascinated by liminal, in-between states and feel comfortable with not knowing, sometimes accepting it as an aspect of infinity, rather than a lack of something. When we look closely, we can notice certain things in a way we might otherwise not pay attention to; tiny little things becoming much more important. I find value in noticing and learning from the discarded, overlooked and thrown away, for their transformative potential in further recycling art making.

AFTERWORD

This book is meant to be about the present. Initially I was hesitant to discuss the past at all, to tint it in any colour. The questions put to each person seemed simple: What do you do every day? How do you start? When do you stop? How has that changed? The responses, of course, unravel any assumption of simplicity – that the present is only about the present. In asking someone how they got to where they are, it inevitably begins at, well, the beginning. It became quickly apparent that any perspective was gained through time, that the artists arrived at their current ways of working through one experience that led to another, then another, and so on. It is also worth keeping in mind that this is a generation that has lived through, among other things, the end of the British Empire, the aftershocks of World War Two; the founding of the European Union; the origins of rock and roll, free jazz, reggae and punk; the inception of digital video, digital photography and conceptual art; the development of cell phones to smart phones and the ongoing reorganisation of knowledge and experience precipitated by the internet. As such, any discussion of the present is implicitly framed by a lifetime of upheaval, dispersal and change, navigated by the personal choices and mistakes we all make.

The expansive portrait this book provides is unique in capturing the processes and spaces of older artists still making work. This isn't just a glimpse into their studios and creative environments, it is also the accidental and hard-won insights they have gained over a lifetime. Cultural figures such as the art historian and television presenter Kenneth Clark, and writers Simone de Beauvoir and Edward Said, have all written on works of art produced by artists of advanced age. A recurring theme in their accounts, though, is what Clark refers to as the 'miserable conditions' of an ageing body, as well as a feeling of exile or detachment that comes with getting older. The aim of these surveys seems only to be to arrive at a general conclusion about 'late style', to find a unified answer or type of work made by older artists. And in every case, the artists they were discussing were long dead. But speaking to such a range of people here has made it more than clear that no such generalising is possible – these are individual lives, still happening and evolving, creating all sorts of styles and approaches, from the flicks and gestures of Bisakha Sarkar's Indian dance to the seemingly casual and incisive moments caught by David Hurn's documentary photography. Time is, for the people in this book, not an enemy but an unvarying, at times strong-willed, companion. The energy and determination I saw in the eyes of each person here rewrite any set narratives about what an artist, of any age, can be.

The different experiences described here do, though, enable a better perspective on our current world. They provide a sense of how society is shifting. On the one hand, opportunities were inevitably different several decades

ago: few of the artists I spoke to received any formal higher education, or only did so later in life. Full-time jobs in theatre, television and publishing, for example, were options available for anyone looking for a creative career – a very different landscape to the current one of perpetual internships, zero-hour contracts and freelancing between multiple jobs. But the hurdles of creativity remain the same, in terms of finding inspiration, maintaining focus and responding to the world around you.

These interviews provide a set of perspectives that amends and elaborates the pervasive histories of the past few decades. There are, undoubtedly, many other names that could have been included, and this is far from a complete representation, but it is an extraordinary and, I feel, accurate one. This book is, after all, also a portrait of a country, made up of artists from all backgrounds who have all in their own way shaped, and continue to shape, the creative landscape of the United Kingdom. Whether born in Accra or Erith, it is this diverse and international set of perspectives that shapes the 'feelings and tremors' of Britishness that painter Frank Bowling speaks about in his interview. These artists provide guiding lights for navigating the present, and a set of inspiring templates for the future.

THE BARING FOUNDATION

Established by Barings Bros Bank in 1969 and independent since the Bank's collapse in 1995, the Baring Foundation is a grant-making charity which protects and advances human rights and promotes inclusion. Amongst other work, the Foundation has always funded the arts in all their many forms, including visual and performance arts.

From 2010–19, the Foundation dedicated its arts funding to activity with older people. This was a relatively neglected issue, especially in comparison to the funding available for arts activity by children and young people. The Foundation's support largely went to 'participatory' arts organisations which use trained artists to work with untrained members of the public. Special emphasis was given to older people who faced barriers to participation, including physical and mental fragility. This work flourished. For a fuller account of how the attitude of arts organisations has changed towards the participation of older people over this period, see *Older and Wiser? Creative ageing in the UK 2010–19* (King's College London, 2019). The Foundation also published a large number of other resources to help support and inspire artists and arts and social care organisations in this field, all of which are available on its website (www.baringfoundation.org.uk).

Alongside the development of this work, sometimes called the 'creative ageing movement', the contribution of a wealth of older artists – some famous, some less so – to the British arts scene has become ever clearer. The Foundation commissioned this publication to celebrate and make visible the working lives of older artists. It includes both those with a lifetime of acclaimed work behind them and some who are newly emerging onto the scene, perhaps having found new creative interests and enjoyments through organisations the Foundation has supported. The Foundation would like to thank everyone involved, especially Chris Fite-Wassilak and Ollie Harrop.

David Cutler, Director, Baring Foundation

SUGGESTED FURTHER READING

Simone de Beauvoir, *The Coming of Age*, trans. Patrick O'Brien, London: Andre Deutsch Ltd., 1972

Kenneth Clark, *The Artist Grows Old: The Rede Lecture 1970*, Cambridge University Press, 1972

Charlotte Parry-Crooke (ed.), *Contemporary British Artists, with Photographs by Walia*, London: Bergstrom + Boyle, 1979

Edward W. Said, *On Late Style*, London: Bloomsbury, 2006

Harvey Stein, *Artists Observed*, New York: Harry N. Abrams, Inc., 1986

BIOGRAPHIES

Chris Fite-Wassilak is a writer based in London. A regular contributor to publications including *Art Review*, *Frieze* and *Tate Etc.*, his book of essays *Ha-Ha Crystal* (2016) is published by Copy Press.

Ollie Harrop is a photographer based in Margate. He has worked with the Tate Galleries, the Freud Museum and Carl Freedman Gallery amongst others, with large-scale commissions at the London Olympic Park and Dreamland, Margate. His monograph *I Love It When You Sing* will be published in 2021.

ACKNOWLEDGEMENTS

Chris would like to thank Marjorie Allthorpe-Guyton, Mark Caffrey, Alfredo Cramerotti, Robert Fowler, Lois Keidan, Rob Le Frenais, Barbara Rodriguez Muñoz, Diana Stevenson and Andrew Wilson for their insight in the initial stages of this project. Thanks also to Kelly Barr, Lorraine Calderwood, Sam Hale, Sian Stevenson and Nicky Taylor for their assistance in reaching the right people, and to Orit Gat and Tyler Woolcott for reading.

Ollie would like to thank Melinda Bronstein, Ian Hall, Jenny Harrop, Simon Terrill and Bon Volks Studios.

Chris and Ollie would both like to give heartfelt thanks to all who feature in the book for sharing their time.